迴歸：廖修平 藝術的符號文脈

Return: The Semiotic Context of Liao Shiou-Ping's Works

2022.9.3—21（9.5—9.7 休館）

國立國父紀念館　博愛藝廊及 1 樓文化藝廊
Bo-ai Gallery & Cultural Corridors (IF), National Dr. Sun Yat-sen Memorial Hall

主辦單位｜ 國立國父紀念館　National Dr. Sun Yat-sen Memorial Hall　台灣美術院　TAIWAN ACADEMY OF FINE ARTS

贊助單位｜ 財團法人 福修文化藝術基金會　Fushiou Culture And Arts Foundation

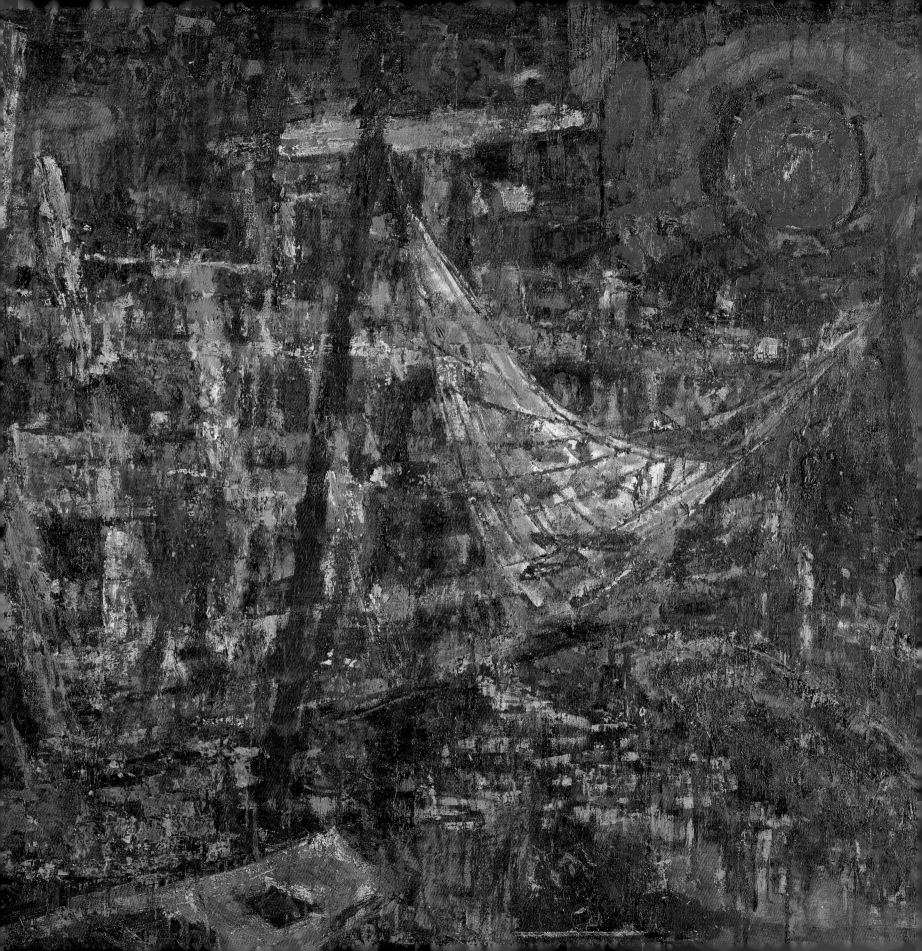

目錄 CONTENTS

迴歸：廖修平藝術的符號文脈

李振明
國立臺灣師範大學美術學系名譽教授

壹、前言

不管是在雲端網路的搜尋或者是從典籍書面資料的檢索，對於廖修平的稱謂與形容，總是常見如下的描述：臺灣版畫家，為臺灣現代版畫先驅、引領者，並有「臺灣現代版畫推動者」之美稱，甚或被譽為「臺灣現代版畫之父」。其緣由不外乎廖修平藝術中，符號文脈識別度、能見度極高的現代版畫創作，為世人所推崇。

加上自年輕在臺灣求學階段繪畫的優異表現，然後赴海外留學發展期間，從東京、巴黎、紐約屢屢獲獎、辦畫展，獲得藝術上的肯定後，如虔誠的佈道者、傳教士般，曾應邀受聘於臺灣師範大學、日本筑波大學、大陸高校及歐美各地授課講學，可謂桃李天下跟隨者眾。在其多項視覺藝術的傑出表現中，或許相對於其他畫種來說，版畫有著較多的技術性竅門傳授，講習的效益較為明顯，受眾能有著更深的感受。而且諸多的晚輩學習者後來也都成為大學高校的版畫教授，不斷開枝散葉的結果，最後終能枝繁葉茂遍地開花。

廖修平在版畫領域的貢獻度確實頗高，因此以上所言似乎也並非僅衹溢美之辭，尤其在亞洲地區，登高一呼，敬仰響應者四面八方匯聚而來，多次舉辦的國際版畫大展、雙年展、學術研討會，設若不是廖修平的主持帶領，恐怕難以促成如此輝煌的局面與績效。

然而，除了為大家所熟悉的版畫成就外，對於廖修平藝術的開創性及其創作符號文脈之體系建構，所積累的可觀成績，或許更值得人們關注審視。

透過進一步的深究與爬梳釐清，讓其藝術的核心本質凸顯，讓廖修平藝術在當代所呈現的意義能更為明晰確立，這恐怕頗值得更多文化史論研究者加以考察的。尤其是廖修平藝術符號語境，所形成系譜軸中最為人所熟知，那挪用自臺灣社會禮儀形式，「門當戶對」的中軸對稱與民俗宗教信仰「經衣¹」紙錢符碼，一再反覆的交相儀式性採用，演繹出的「儀式幸福感」，並擴衍出深具個人獨特性視覺識別度風格的藝術體系。

漂浪──迴歸，從臺北踏出、東京、巴黎、紐約、再回臺北，廖修平用一生體現對腳踩泥土的眷顧、對土地上人們的關照，在自己安身立命後印證的豐富藝術歷程，頗值得研究。關於廖修平創作時

1 〈經衣紙錢印記〉，《國立臺灣歷史博物館典藏網》，經衣又稱巾衣、更衣，屬金銀紙錢中之紙錢類，用於祭祀亡靈、孤魂等，其特徵為紙錢面幅印製多樣梳洗用具與衣物，主要在提供亡靈梳洗與更衣之用。臺灣民俗重視無主孤魂之祀，在陰曆七月初一日「開鬼門」之後，家家戶戶都要在門口祭祀俗稱好兄弟的孤魂，稱為拜門口，地方公廟則舉行普度。祭祀孤魂時要先燒化經衣以供梳洗更衣，收供品前再燒化銀紙以享孤魂。https://bit.ly/3BzQzB0 ，（2022/7/22 檢索）。

間序的傳承與養成脈絡，已經有不少的論述，本文試圖從廖修平藝術創作的符號文脈來做一番梳理探討。

貳、共時性的藝術結構

世界地球村的逐漸形成，緣於強調在地特質所生發的共時性國際藝術思潮，讓原本認為藝術應當是一種國際共通語言，沒有地域性差異的理念，變得在地性更得以國際性。瑞士心理學家榮格（Carl Gustav Jung，1875-1961）所提出的共時性（Synchronicity）這個「有意義的巧合」概念，揭示了主體世界與客體世界之間充滿著具意義的連結，它溝通了人與人共存關係的邏輯和心理聯繫，從而形成體系。

戰後藝術前趨舞台之一的美國紐約，在 1960 年代出現普普藝術（Pop Art，又譯為波普藝術或通俗藝術），這麼一個探討通俗文化與藝術之間關連的藝術運動。藝術家試圖推翻抽象表現藝術並轉向符號、標誌等具象的大眾文化主題。來反映當時美國社會現象中，藝術當貼近普羅平民大眾美感經驗的想法，其代表性藝術家，安迪·沃荷（Andy Warhol 1928-1987），是視覺藝術運動普普藝術的開創者之一。他常透過絲網版印複數性特質的手法來進行藝術創作，美國社會人們熟悉的名人圖像、生活飲食隨處可見的視覺媒體符碼、美國社會裡的知名品牌標誌等，都成為他的創作符號。藝術家抱持著藝術生活化、世俗化的觀念，對現代文明抱持著樂觀肯定的態度，將大家所熟悉的大眾傳播影像，作為藝術表現的題材。安迪·沃荷探討美國的大眾文化，運用社會生活習見的可口可樂瓶、康寶濃湯罐頭，明星瑪麗蓮夢露等圖符，體現出藝術與大眾親近的「流行藝術」（Popular Art）。（圖 1）

曾經長時間生活工作於美國社會的廖修平，嘗試也透過版印（蝕刻金屬版、絲網版）藝術品的複數性表現，來凸顯他本來就堅信的理念：「藝術源自於生活」。只是他創作的符號更多源自於故鄉世俗生活的經驗，異鄉那快速且不斷反覆的紐約都會生活步調，廖修平或許有些無奈，卻又必須面對，但也較難以興發自在的感動。此時，廖修平熟悉演練之版印藝術的複數性表現，一方面反映快速且不斷反覆的美國都會生活，一方面也藉售畫用以支應長期家用的生活經濟開銷，因為這也是他這個一家之主必須的擔當[2]。創作於 1975 年的〈龍門〉（圖 2）蝕刻金屬版畫，反映著斯人期待跨過彩虹魚躍龍門的願望。

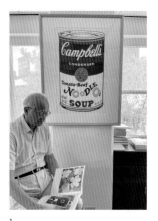

1.
廖修平與收藏安迪·沃荷作品合影
A photograph of Liao Shiou-Ping and his Warhol original.

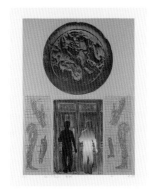

2.
廖修平〈龍門〉
蝕刻金屬版畫
1975
Liao Shiou-Ping
Gate of Dragon
Etching
1975

2 據廖修平本人所言，雖廖家在臺灣的財力，不會不足以支助這位當藝術家的四子。總是愛子的廖母嘗言，家中九個孩字，每個少吃一口飯就夠他吃了。但是實際上，父親廖欽福勤儉持家及男子當自強的家訓，讓他仍須藉由較易銷售的版畫，來取得經濟上的回饋以支應家用，這當中當然也因為有代理畫廊的肯定與藏家的青睞。

一直以來，廖修平海外時期的創作，其共時性的藝術結構，創作的符號卻未必就是反映異鄉當下的現實世界。那原鄉心靈深層的藝術結構語言，那些來到異鄉前，幼時以來留存的魂縈夢繫影像，總是浮現腦門。那些童年住居所在，臺灣日治時期遺留下來的日式宿舍，出出入入之門檻窗格的生活記憶（圖3）；農曆的每個月初一、十五，讓母親牽著手到附近龍山寺上香拜神，望著兩尊大門神的景象彷彿依稀，初一十五祈福的儀式性行為，似乎已成一種制約反映的舉止，其他如過年過節與民俗廟會活動的宗教儀禮，印象依然烙印深刻永難忘懷。這般回應彼時華人共時性的藝術結構，具有民族特色的現代藝術，而繪畫符號卻迴映著過往生命記憶的創作文脈做法，似乎也可從夏卡爾的個案取得例證。

夏卡爾（Marc Chagall，1887—1985），是白俄羅斯猶太裔的俄法著名藝術家，長時間生活工作於巴黎，活動於巴黎。被稱呼為「超現實派」的夏卡爾，一輩子的藝術創作游離在印象派、立體派、抽象表現主義等多流派間，其作品製作形式包括繪畫、素描、彩色玻璃、舞台佈景、陶瓷等。他夢幻般色彩的畫作，呈現出具象卻富於象徵性的手法。少時生活所見的屋宇農舍、鄉人的婚禮、演奏著小提琴的人等活動，村落裡的牛、馬、羊、雞等現實生活情境與夢想，還有俄羅斯民間傳說等，都是夏卡爾的創作泉源，也組構出他「超現實派」繪畫的符號系譜語境。

從臺北龍山寺廟埕口的成長開始，廖修平在地的生命經驗，那反芻自土地所給予的養分，由民間 - 而廟宇 - 而學術殿堂，最終接軌國際藝術思潮。藉由一己一生的開拓，其藝術成就所形塑的典範，揆諸世界戰後當代藝術所映現的諸多繪畫現象，他所構築的藝術符號文脈，恐怕並非只是臺灣或是華人世界所指涉的地方性意義而已。戰後共時性藝術風貌，成為藝術家追求的目標。其中，我們見出深信藝術源自於生活的廖修平繪畫（主要有油畫、版畫與複合媒材），透過臺灣常民文化中的廟埕意象（圖4）（圖5），予以解構重組或是錯置另配，擴衍出深具個人獨特性視覺識別度風格的藝術體系。這是廖修平的延異開展，同時也是生活於這塊土地臺灣人的共同經驗，也或許是一種集體潛（無）意識，最終構築出廖修平的藝術典範，同時也是放諸國際依然綻放光彩的風華。

廖修平這樣一位能在美術史留名的重要藝術家[3]，其藝術成就的端顯，媒材與技法恐非主要的重點，此回個展廖修平又更另闢一脈，展出多件具東方特質的水印木刻版畫演繹創作，因此，藝

3 廖仁義，〈樸素的符號與高貴的美感─全方位的現代藝術大師廖修平〉，《臺灣美術全集36-廖修平》（臺北：藝術家出版社，2018），頁17-31。

3.
廖修平〈靜物〉
絲網版畫
1976
Liao Shiou-Ping
Still Life
Silkscreen print
1976

4.
廖修平〈七爺八爺〉
油畫
1959
Liao Shiou-Ping
*The Tall God and
The Pudgy God*
Oil on canvas
1959

5.
廖修平〈祭神〉
油畫
1963
Liao Shiou-Ping
Worship
Oil on canvas
1963

術風格的建構方是關鍵，而藝術風格的建構，更在乎個人藝術獨特性的符號體系。就如個人藝術視覺識別度皆高的安迪‧沃荷與夏卡爾，其劃時代的風格似乎也都建立在「我曾在」的生活體驗之中。

叁、創作符號的延異

1964-1968 年留學法國期間，應該是廖修平藝術進入符號文脈建構體系的開端。起初於 1965 年進入巴黎高等美術學院學習油畫，後來進入海特（S. W. Hayter, 1901-1988）創辦的十七版畫工作室（Atelier 17）開始研習蝕刻金屬版畫，這段期間除了熟習運用一版多色凹凸法的金屬版畫技術，對於廖修平一生的創作也是一個重要轉捩點。從原本架上繪畫的具象描寫，轉而進入符號建構與肌理紋路的探討。由於蝕刻金屬版畫，確實非常適合表現如青銅器銅綠銹蝕的肌理、漆器剔紅剔犀、鏍鈿百寶嵌等，中國傳統器物豐富而多層次的紋理符號。如 1966 的〈敬虔〉、1967 的〈太陽〉、〈月亮〉、〈星星〉等，再加上象徵門、春聯圖式的《門之連作》系列油畫（圖 6-11），種下了日後符號系列建構發展延伸的基礎。這在當時交往濟濟的西洋藝術家群中，突顯了做為一位來自東方藝術家創作的別出風格樣貌，尤其這些寺廟民俗符號語彙，讓他尋找到屬於自己文化根源的創作元素，同時也是身處異鄉的他，抒解鄉愁的一種聊慰。

深刻影響結構主義和解構主義的瑞士語言學家索緒爾（Ferdinand de Saussure, 1857—1913），創立了符號學，他認為結構並非單一的元素，也就是說結構關係著符號彼

6.
廖修平〈太陽〉
蝕刻金屬版畫
1967
Liao Shiou-Ping
Le Soleil
Etching
1967

7.
廖修平〈月亮〉
蝕刻金屬版畫
1967
Liao Shiou-Ping
La Lune.
Etching
1967

8.
廖修平〈星星〉
蝕刻金屬版畫
1967
Liao Shiou-Ping
L'etoile
Etching
1967

9.
廖修平〈敬虔〉
蝕刻金屬版畫
1966
Liao Shiou-Ping
La Dévotion
Etching
1966

10.
廖修平〈門之連作〉
油畫
1966
Liao Shiou-Ping
Gate
Oil on canvas
1966

11.
廖修平〈門之連作 # 66-10〉
油畫
1966
Liao Shiou-Ping
Gate #66-10
Oil on canvas
1966

此之間的差異而產生，再者，符號的意義主要由該符號與其他符號之間的關係來決定。其關係就是所謂的系譜軸和毗鄰軸，系譜軸在符號轉換過程中扮演著選擇的角色，而則是一個元素從系譜軸裡被選擇出來後，與其他元素組合的一個橫向作用的意義延伸。

廖修平藝術作品形式多元、探討的面向不少，其創作符號文脈所形成之系譜軸，主要源自臺灣社會民俗禮儀形式，「門當戶對」、「出入雙喜」的中軸對稱以及宗教信仰「經衣」紙錢符碼，所演繹出的「儀式幸福感」，並擴衍出毗鄰軸的藝術體系。以下嘗試分析其藝術創作符號的延異特質：

一、「門當」「戶對」的中軸對稱形式

如對開的大紅門般，中軸對稱式構圖，一直是廖修平藝術創作的常見形式。這種形式，在普遍傾向於畫面不對稱平衡的西方藝術，確實較為乏見。其形式乃是物件的一半為其另一半的鏡射，二維畫面的對稱軸，將其兩邊的物件，安置於有同樣距離的對應。這種對稱的穩健，在歷來的華人社會，其肅穆端莊的特質，所展現的中規中矩符合禮節，是被肯定而嘉許的。而在西方藝術家眼中或許會覺得如此畫面過於刻板少變化，顯得不夠活潑。可是在禮儀之邦華人傳承的文化裡，卻是從小被諄諄教誨，行禮如儀的良好教養象徵，並且是獲致人生幸福的保證。

中軸對稱形式固然有著讓畫面安定而穩健的考量，在廖修平創作歷程中，緣於從兒時以來的生活經驗與良好的家教，或許更是濃烈而深刻。那是生命底層的悸動與呼喚，是一種創作發想過程隨緣自在的自然意象湧現。

門當戶對一詞，在華人社會觀念中，一般乃是衡量男婚女嫁條件是否相稱配合的一個成語。而其原意，「門當」其實就是門擋，是位於大門兩旁的一對石墩（或石鼓），是用來鎮宅及裝飾的。講究者門當上會有各式雕刻，其中鼓形的門當是代表武官的府邸，箱形的門當是代表文官或百姓的宅第。而「戶對」則是門楣上的磚雕或木雕凸出物，形狀多為圓柱形、方柱形及六角柱形，柱端會有裝飾花紋或文字，用於家有喜慶時懸掛燈籠之用。（圖 12）

12.
「門當」和「戶對」
"Men dang" and *"hu dui."*

「門當」和「戶對」除了有鎮宅裝飾的作用，還是府宅主人身份、地位、家境的標誌。「門當戶對」後來乃逐漸演變成社會觀念中衡量婚姻是否匹配的一個用語。廖修平藝術創作中常見的中軸對稱形式，繪畫構圖如對開大紅門般的色面，在在顯現出其對原來符號的延異，在自我藝術風格的構建過程，借用也轉化了文本的明晰性，圖形在衍化中將一種形象通過一定過程再演變成另一種形

象。廖修平藝術創作畫面中的符號延異形式，也就成為他個人獨特風格的辨識特質。（圖 13.14）

二、從雙喜到曼荼羅的圓滿幸福

「紅美──黑大方」是一句臺灣妝扮配色常用語，原色的紅與黑，象徵美好而莊重。廖修平常用以作為畫面色彩配置，搭配囍（雙喜）[4] 符號到成雙數的符碼，表現富貴幸福感的符號文脈。（圖 15）不同於西洋人偏好單數的 7 這個數字，往往認為 lucky 7 是幸運的喜兆 [5]。另外，東方文化中，象徵圓滿幸福，以圓、方、菱形符號，相對應不斷漸層擴衍開展的圖式，也總是習見於生活、宗教、民俗中。自古印度以來的佛教文化曼荼羅圖式，即是其中的一個典型範例。

曼荼羅（梵語：मण्डल Mandala），原義為圓形，意思為「壇」、「聖圓」、「中心」、「輪圓具足」等。原本是古印度瑜伽修行所建造的一個小土台，後來也用繪圖的方式製作，屬於佛教藝術中變相的一種。（圖 16）佛教承傳自印度叢林修行靜思凝念的圖式，所形成許多不同形式的曼荼羅，它是修持能量的中心，從中央同心圓向外漸層，所做的萬象森列圓融有序的佈置，代表著生生不息的漣漪般衍泛。

4 囍是喜慶用字，讀音同喜，俗稱雙喜。在中國大陸、台灣、韓國、越南、琉球，多用於婚嫁等場合，意思是對男女兩家都是喜事。常以紅、金箔紙剪製粘貼，以示喜慶。

5 一直以來，在聖經中表示完整的意思，聖經的創世記中寫道，上帝用 6 天造物，定第 7 天為休息日，所以一個星期有 7 天，對人類而言也就把 7 看為是幸運的數字。另外 lucky 7 是由賭場的擲骰子遊戲而來，兩顆骰子擲出總和為 7 便是勝利，是賭徒運氣的標誌，也是演變成幸運數字 7 的由來。

13.
廖修平
〈東方之門（二）〉
複合媒材
1974-80
Liao Shiou-Ping
Gate of Oriental II
Mixed media
1974-80

14.
廖修平
〈迎福門 一〉
複合媒材
2010
Liao Shiou-Ping
Gate of Prosperity I
Mixed media
2010

15.
廖修平〈雙喜〉
蝕刻金屬版畫
1966
Liao Shiou-Ping
The Double Joys
Etching
1966

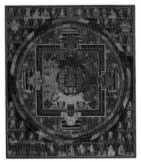

16.
〈曼荼羅〉唐卡
Mandala. Thangka.

對於曼荼羅圖式的認知，一般總是讓人聯想到藏傳佛教的唐卡，那由中向上下左右四方漸層衍化所象徵的圓滿具足。

即使放下宗教的思維，心理學家榮格認為曼荼羅象徵著目標中心點，是一種走向中心之心理過程的自我復現現象，其概念可以由圓、方或菱形向四方象徵性的復現出來。作為心理整體的自我，是一種相對安定衍化的狀態。榮格認為集體潛（無）意識是人格中最深刻、最有力的部分，它是人類祖先經驗的積累所形成的一種原型。就在我們每個個人的深層意識當中，有一個不源於個體生活經驗的意識根源，通過象徵的方式建構內心的平衡與秩序。

而儒家思想當中，《大學》裡所言：「定、靜、安、慮、得」之五字經，對人生安身立命的生活智慧，似乎也是一種相互的印證，而這些涵養終消化成為廖修平藝術創作的立基。（圖17.18.19）

1960 年代，臺灣現代藝術的濫觴，大約在 1950 年底、1960 年初開始，也就是強調現代主義的時代，當時引西潤中、中西融合的論辯，促發現代繪畫運動的蓬勃發展。五月畫會、東方畫會與今日畫會等，掀起現代主義繪畫熱潮，加上 1961 年由徐復觀發表〈現代藝術的歸趨〉文章，劉國松、虞君質等人爭辯的現代畫論戰，對台灣現代藝術的發展起了不小的推進作用。

這時期的臺灣畫壇，除了藝術強調現代主義，繪畫中象徵圓滿幸福，以圓、方、菱形符號，相對應開展的曼荼羅圖式，以及紅、黑色彩，似乎也是當時畫家們畫面常見的運用。這確實是個有趣而值得探討的命題，即使刷染抽筋剝皮皴水墨表現的劉國松亦不乏見這種現象[6]。

17.
廖修平〈陰陽〉
蝕刻金屬版畫
1970
Liao Shiou-Ping
Yin and Yang
Etching
1970

18.
廖修平〈福門 20-C〉
複合媒材
2021
Liao Shiou-Ping
Gate of Fortune 20-C.
Mixed media
2021

19.
廖修平〈福（一）〉
絲網版畫
2019
Liao Shiou-Ping
Good Fortune I
Silkscreen print
2019

6　王德育，〈劉國松繪畫中圓之意象〉，李君毅主編，《劉國松研究文選》，（臺北市：國立歷史博物館，1996。），頁174-192。另外也常見於當時畫家秦松、霍剛、陳庭詩、李錫奇等畫中。

三、延異「經衣」符碼的儀式性採用

廖修平藝術「經衣」符碼的出現，是在留學法國時期（1964-1968）開始醞釀，先是油畫與蝕刻金屬版畫，再到絲網版畫。由於絲網版畫的方便性與印製工坊的協作，其數量與普及能見度最高。正好也呼應現代藝術所倡言，藝術貼近生活與大眾的理念。

延異「經衣」符號意義的創作，最早是在廖修平海外學習與生活時期。他總是懷想著臺灣故鄉土地上的種種生命經歷，在兒少時，除了常常跟母親到離家不遠處的龍山寺拜神時，感受到的香火裊繞煙霧瀰漫外，印象特別深刻的是，在每年農曆七月，中元普渡[7]大拜拜的熱鬧記憶，以及祭拜「好兄弟」儀式過程的點點滴滴經驗。在供品擺案後，燒香祭拜前，有一道特別不一樣的做法印象，也就是燒「經衣」紙錢的儀式。（圖 20）

20.
「經衣（更衣）」紙錢
Jingyi (gengyi)
joss paper

中元普渡時，用來燒給好兄弟的紙錢，依據臺灣民俗文物辭典所載，「經衣」又稱「更衣」，臺灣北部、中部的經衣尺寸較大，一般為一尺乘三寸五；南部地區所慣用的經衣則尺寸非常袖珍，為黃紙上面印綠色的圖案。經衣上面印有男性和女性的衣服（男性為上衣、長褲；女性為上衣、長裙）、靴子、梳子、剪刀、鏡子、扇子的日常生活器具。一般用於農曆初一、十五或初二、十六拜門口，或是中元普渡建醮普渡祭祀好兄弟時所用[8]。

中元普渡的儀式，從最初農民在夏末秋初祭祀田神、土地的習俗，到家家祭祀祖先，祭祀亡者靈魂、構成漢字文化圈的一系列祭祀活動，供奉時行禮如儀。儀式性意義經過不斷輾轉延異，則已有不同演繹。

儀式（ritual），在精神分析用語上，可解釋為「形成固定模式或強迫性的反覆行動」。然而儀式也可能是產生創意和達成目標的重要因素。儀式以一個單一概念串在一起形成一種共通認知，所

7 中元節的出現不會遲於漢代，最初是農民在夏末秋初祭祀出神、土地的習俗，祈求五穀豐收、感謝大地的節日。這季節民間按例要祭祖，因此每到中元節，家家祭祀祖先，供奉時行禮如儀。加上宋朝儒、釋、道三教合流，道教中元節的祭祀亡者靈魂、佛教盂蘭盆會的施餓鬼、儒家祭祀祖先等活動，加上各地巫覡宗教如中國巫覡宗教、日本神道教、朝鮮巫教、琉球神道結合，構成漢字文化圈的一系列祭祀活動。見〈中元節與盂蘭盆節〉，《維基百科》，https://bit.ly/3ORnow6，（2022/7/21 檢索）。

8 〈經衣（更衣）〉，《臺灣民俗文物辭典》，國史館臺灣文獻館，https://dict.th.gov.tw/term/view/1406。（2022/7/21 檢索）。在閩南、臺灣、新馬華人地區，特指無後人奉祀的亡魂為好兄弟。中元普渡使用「更衣」要分飯前（插香後）與飯後（拜拜禮成）兩次使用。在普渡祭拜好兄弟前，先焚燒數疊印有衣褲圖案的「更衣」，象徵給好兄弟梳洗打扮後來享用祭品。一方面不方便請好兄弟進門，另外也是因為門神會讓好兄弟無法進門享用食物，所以俗稱「拜門口」。飯前燒「更衣」具有「邀請函」的功能，所以也不能燒太多，要配合供品多寡，免得罪了吃不到祭品的好兄弟。至於剩下的「更衣」，在普渡後隨銀紙焚化即可。這是讓吃飽的好兄弟隨手帶走當伴手，當一年的生活衣物，飯後則可以將「更衣」全部燒完。〈中元普渡必備「更衣」使用說明〉，https://bit.ly/3oNshfe，（2022/7/22 檢索）。

謂的儀式感，未必是具體、物質層面的行為，更像是一種認真對待的態度。儀式或許未必帶來幸運，但因儀式感而起的自覺，將使人開始思考重塑價值與意義。進而豐富自信，增加愉悅感。儀式是一組預先設定好的反覆性、象徵性動作序列，缺乏直接的效用。首先，它由固定連續發生的行為組成，一個接一個，並以形式和重覆為典型；其次，這些行為具有象徵意義，最後，這些儀式化的行為通常沒有明顯目的。但儀式性的做法有助於給不確定的未來帶來一定程度的可預測性。緩衝不確定性所帶來的焦慮，在某些情況下，甚至只是觀察儀式未必直接參與。

跨越世代，經過時序的轉換，另類的紙錢運用再儀式化，也出現在不同的藝術創作展演情境，對照於臺灣當代重金屬音樂社群，閃靈樂團演唱會現場於散場時，樂迷都固定會往空中拋撒大量的冥紙，用來對歌曲描述的祖先和靈魂表示敬意。

撒冥紙這個動作在 1998 年閃靈發行單曲之後的演出開始出現，爾後這個動作逐漸變成看閃靈表演的一個必要的動作，漫天飛舞的冥紙場景也成為閃靈演唱會傳統的一部分。經過了二十年之後，有部分樂迷也會在其他臺灣金屬樂團的演出中撒冥紙，那是資深樂迷對於音樂投入情感且陶醉的一種表徵。

不同的是，廖修平延異「經衣」符碼的再儀式化採用，或許較接近於西藏五色風馬旗（經幡）祈福的概念。在西藏地區，人們隨處可見印有經文的風馬旗（紙）飄揚著，就像是藏區的大地景觀藝術。風馬旗寄託著人們美好的願望，普遍象徵祝福和祈禱的含義。（圖 21）

關於人類儀式性行為的研究，發跡於英國的波蘭人類學家布羅尼斯瓦夫‧馬林諾夫斯基（Bronislaw Malinowski 1884—1942），認為信仰和堅持儀式，能幫助人們應對工作的不確定性和危險性。這位被稱為民族誌之父的人類學家，在 20 世紀初訪查巴布亞新幾內亞的特羅布裏安群島（Trobriand Islands）時，記錄了島民們在冒險出海之前會進行的一長串儀式，而島民舉行的儀式是為了幫助他們應對太平洋不可預知的力量。

從圓、方、菱形符號，到對應開展的曼荼羅圖式，以及紅、黑色彩的運用，開始建構屬於廖修平藝術體系的符號語境。而藉由臺灣民俗宗教信仰「經衣」紙錢符碼所形成的系譜軸，衍生之符號視覺體系，更演繹出一種「再儀式化」的「儀式幸福感」。原先的意義，在不斷向外擴散的過程，逐漸轉化消解，延異了「經衣」符號的原來儀式化採用，意義又不斷地生成、轉換，又不斷消失，甚至消解了意義的本身。最終象徵的意義，則帶有祝禱和祈福的含義。從生活的切身體驗出發，

21.
五色風馬旗—
象徵祝福和祈禱
Tibetan prayer flags, said
to represent blessings and
prayer.

面向生命主體的關照，廖修平對在地泥土與人們的眷顧，成就了他藝術創作最主要的符號文脈。（圖22.23.24.25）

肆、結論

對於普普藝術大師，一般大家並不會只以現代傑出版畫家來形容安迪‧沃荷，因而即使只是形容廖修平為臺灣現代版畫的開拓領航者，甚至稱之為臺灣現代版畫之父也還是不公平的。固然廖修平對於版畫推動的不遺餘力成果豐碩。但是廖修平藝術的價值，恐怕不僅止於此，一生的投入與開拓，從海外發展到迴歸心靈的原鄉，其個人創作整體的藝術成就和定位，應該更值得加以關注。

戰後國際地球村的形成，人們的互動更為靠近與頻繁，現代藝術倡言藝術貼近大眾的生活，其中絲網版印藝術的創作，讓藝術得以普及化。如果當代藝術論述創作的最高意義並不在於實體物件，而是在創作的理念與個人獨特風格辨識度的凸顯，廖修平運用臺灣社會民俗禮儀「門當戶對」的中軸對稱與宗教信仰「經衣」等符號的儀式性延異，開拓出其個人藝術符號世界的創作系譜，其藝術理念的形成與建構是完整而具時代意義的，確實是值得敬重的。

2022年九月在國立國父紀念館博愛藝廊的個展【迴歸：廖修平藝術的符號文脈】，除了經典代表作回顧，廖修平又推出一系列，融合水印木刻版畫的「經衣」符號再延異作品，傳統水印加手作的水墨複媒創作，探討版印的準確性與墨染的非完全操控性之間的微妙互動。似乎在告訴人們，將屆九十的他，不停的馬蹄依然持續向前！

22.
廖修平〈紅的節日〉
複合媒材
1968
Liao Shiou-Ping.
Red Festival
Mixed media.
1968

23.
廖修平〈福門 20-G〉
複合媒材
2020
Liao Shiou-Ping
Gate of Fortune 20-G
Mixed media.
2020

24.
廖修平〈六福之門〉
複合媒材
2020
Liao Shiou-Ping
Gate of Fortune
Mixed media
2020

25.
廖修平〈希望祈求〉
油畫
1969
Liao Shiou-Ping
Hope
Oil on canvas
1969

Return: The Semiotic Context of Liao Shiou-Ping's Works

Lee Cheng-Ming

Professor Emeritus, Dept. of Fine Arts, National Taiwan Normal University

I. Preface

Whether searching on the internet or within written texts chronicling the classics, the titles and descriptions used to describe Liao Shiou-Ping are often as follows: Taiwanese printmaker; a pioneer and leader of Taiwanese modern printmaking; the Promoter of Taiwanese Modern Printmaking; and the Father of Modern Printmaking in Taiwan. In viewing Liao's artworks—modern prints with highly recognizable semiotic context and high discernibility—it isn't difficult to discern why he has such a shining reputation and why he is held in such high esteem by the international community.

Liao showed exceptional talent in painting during his schooling in Taiwan, and during his time spent abroad, he won numerous awards and held exhibitions in Tokyo, Paris, and New York. After gaining artistic recognition, he traveled far and wide, accepting teaching positions and lecturing at Taiwan's National Taiwan Normal University, Japan's University of Tsukuba, various Chinese high schools, and numerous institutes in Europe and the United States. Perhaps, out of the extensive list of artistic techniques he is accomplished in, printmaking requires more technical finesse to master; the results of listening to his teachings are more concrete, leaving students with the feeling of having genuinely learned something. Many of these pupils have gone on to later become printmaking professors in universities and colleges, allowing the technique to continually spread and bloom.

Indeed, Liao has made a great number of contributions to the field of printmaking, but the aforementioned recounting of his feats is not just an act of praise—rather, it's to reinforce his position of high standing in the global realm. His reputation gathers admirers from far and wide, especially in the Asian region; the success of several international printmaking exhibitions, biennales, and academic seminars would have been difficult to achieve were it not for Liao headlining the events.

Nevertheless, in addition to his well-known achievements in printmaking, the accumulated results of his pioneering artworks and systematic construction of the semiotic context within them may be even more worthy of attention and analysis.

Through ardent research and inquiry, it was possible to pinpoint the core essence of Liao's art, and, in turn, more clearly establish the significance of his art in contemporary times. This is probably a topic worthy of further investigation by cultural history researchers. In particular, the symbolic context of Liao's art includes the paradigmatic adoption of symbols and concepts commonly encountered in Taiwanese society and rituals—the axisymmetry of "*men dang hu dui*" and the folk religion symbols of *jingyi*[1] joss paper—which are repeatedly re-ritualized; eventually, this process results in a feeling of "happiness found in rituals," as well as amounts to the expansion of his creative style into a deeply personal, unique, and visually recognizable form.

From the start of his journey, beginning in Taipei—then drifting among Tokyo, Paris, and New York—to his eventual return to his homeland, Liao Shiou-Ping has spent his entire life expressing his love for the earth and people of his native land through his artwork. His rich experiences in art after his move back to Taiwan are yet another topic worthy of looking into. There have already been many discussions on the chronological development of Liao's creative approach; this article, however, will attempt to explore and examine the semiotic context of Liao's works.

II. A Synchronic Artistic Structure

The gradual formation of the global village is a result of synchronic international artistic trends of thinking that emphasized local characteristics, which al-

1 "*Jingyi joss paper stamps,*" National Museum of Taiwan History Online Collection, accessed July 22, 2022, https://bit.ly/3BzQzB0.

"*Jingyi* (literally 'threads and clothes'), also known as jinyi or gengyi, are a type of joss paper burnt as offerings to the spirits of the deceased and wandering ghosts, characterized by the images of toiletries and clothes printed on them. They are burned to allow spirits to cleanse themselves and change clothes. Taiwanese folklore attaches great importance to the worshipping of wandering ghosts. After the opening of the gates of hell on the first day of the seventh lunar month, it's common to see people offering food and incense to these ghosts (also called 'good brothers') on tables placed in front of their homes, known as *baimenkou*; local temples will organize pudu or 'Ghost Festival' events. When making offerings to wandering spirits, one should first burn *jingyi* so that ghosts can wash up and change before eating. Silver joss paper should be burned as offerings to lonely ghosts before clearing away food offerings from the table."

lowed for the general perspective of art to transform from its initial concept as a shared international language without regional differences into something more globally local. The concept of synchronicity or "meaningful coincidences," proposed by Swiss psychologist Carl Gustav Jung (1875–1961), reveals the abundant meaningful connections between our subjective and objective realities; these connections convey the logical and psychological connections that exist in human cœxistence, which subsequently form a system.

Pop art is an art movement that emerged in the 1960s in New York, one of the cities at the forefront of post-war artistic development, and explored the connection between popular culture and art. Artists attempted to overturn abstract expressionist art, turning to concrete symbols and imagery from popular and mass culture. The pop art movement, then, originated as a reflection of what would happen if art more closely resonated with the æsthetics of the general public in America at that time, and one of the representative and leading figures of this movement was Andy Warhol (1928–1987). Warhol frequently utilized silkscreen printing as an artistic technique, adopting various cultural imagery familiar to the American public as the subject matter of his creations—ranging from the faces of well-known celebrities, to likenesses of common foodstuffs, to well-known brands. Through the secularization of daily life and our possessions, pop art transformed familiar mass media images into creative symbols within artworks, viewing modern civilization through an optimistic and affirmative lens. Warhol's explorations of American popular culture through the use of ubiquitous symbols such as Coca-Cola bottles, Campbell soup cans, and images of Marilyn Monroe demonstrate the elevation of everyday items into fine art as "popular art" (Figure 1).

Liao Shiou-Ping, who had been living and working in the United States for a considerable length of time, began experimenting with printmaking (etching and silkscreen printing) to produce multiple copies of his works as a display of his belief that "art stems from life." However, since the majority of the symbols utilized in his creations were derived from secular life in his hometown, Liao might have felt somewhat powerless faced with the fast and constantly changing pace of life in the foreign land of New York City. He had no choice but to endure the circumstances, but also found it difficult to summon inspiration from within. On one hand, the proficient prints from this period in Liao's life reflected the fast-paced, repetitive urban lifestyle in the United States; on the other, they were his means of fulfilling his obligations as the head of his family to financially support them.[2] His 1975 etching *Gate of Dragon* (Figure 2) depicts the desire of people to leap over the rainbow and Dragon Gate to achieve success.

The synchronic artistic structure of Liao's overseas creations and the symbols within them did not necessarily reflect his then reality in a foreign land. The deep-seated artistic structure stemming from life in his hometown; the haunting, dream-like images he had stored away since childhood—they continually crossed his mind. Memories surfaced of the front door threshold he stepped over daily as a youth in the Japanese-style dormitories his family lived in, remnants of the Japanese occupation of Taiwan (Figure 3); on the first and fifteenth day of every lunar month, his mother would take his hand and lead him to the nearby Longshan Temple to pray and offer incense to the gods, and he vaguely remembers looking up at the two colossal *menshen* ("door gods"). The ritual of praying for blessings on the first and fifteenth of the lunar month seem to have become a sort of conditioned response. Other religious rituals, such as Chinese New Year's and temple festival celebrations, have left a long-lasting impression on Liao, powerful and unforgettable. These memories evoke the synchronic artistic structure shared by the Chinese of that time period, who merged modern art with cultural characteristics. The creative technique of depicting symbols and motifs drawn from past recollections is a practice shared by Marc Chagall.

Chagall (1887–1985) was a famous Russian-French artist of Belarusian-Jewish descent, who lived and worked in Paris for a long time. Known as a surrealist artist, Chagall spent his entire life shifting among the Impressionist, Cubist, abstract expressionist and various other art styles; his works spanned a range of formats, including paintings, drawings, stained glass, stage sets, and ceramics. The dream-like colors of Chagall's paintings accentuate his use of symbolic imagery. Recollections of a wedding held in the village when he was younger, surrounded by houses and farmhouses, accompanied by people playing the violin; real-life situations and dreams concerning the cows, horses, sheep, and chickens in the village; as well as Russian folklore—all were sources of inspiration for Chagall, and they also constitute the semiotic context of his "surrealist" paintings.

2 According to Liao himself, the financial status of the Liao family back in Taiwan would be sufficient to support the artist and his four sons; Liao's mother, who loved her son, said that if his eight siblings ate one less spoonful per meal, it would be enough for Liao to subsist on. However, due to his father Liao Qin-Fu's frugal household budgeting and the family belief that "men should be self-reliant," Liao felt compelled to support his family through prints, which were easier to sell. He also benefitted from the support of galleries and collectors.

From his childhood spent growing up in front of Taipei's Lungshan Temple, Liao Shiou-Ping's grassroots beginnings, grounded in his native soil, informed his creative trajectory—the progression from folk culture to temple life, formal art training, and finally, integration with international artistic trends. Liao has cemented his status as an exemplar in the art world through his life-long pioneering achievements; his numerous post-war creations and the semiotic contexts depicted within them transcend regional connotations limited to Taiwanese life or even those of the overall Chinese community. Artists aspired to attain a post-war synchronic artistic style, and among them, we can set apart Liao from his fellow creators. Liao, who holds a firm belief that art is rooted in life, has produced a body of work which mainly consists of oil paintings, prints, and mixed media creations. Over the course of his career, Liao has established a deeply personal and uniquely identifiable style, created through the deconstruction/reconstruction and displacement/misplacement of cultural images belonging to the everyday temple culture of Taiwan (Figures 4 and 5). This exhibition simultaneously presents the evolution of Liao's *différance* and the shared experience of the Taiwanese people inhabiting the island. It may also be that this collective subconsciousness/unconsciousness, which shaped Liao's artistic framework, was also instrumental in boosting him into the limelight in the global art community.

For an important artist like Liao who has already made a name for himself in art history,[3] the end results of his artistic achievements, his chosen mediums or techniques—these are not our main focus. In this solo exhibition, Liao has adopted a different approach, exhibiting a number of woodblock prints featuring oriental attributes; thus, how the artist founded their artistic style is the heart of the matter, and artistic style is based upon one's own unique semiotic system. Just like in the easily-recognizable works of Warhol and Chagall, their epoch-making art styles all seem to be based in one's personal life experiences.

III. The *Différance* of Creative Symbols

The period Liao spent studying abroad in France from 1964–1968 is most likely when he first began forging his own semiotic context. He began at The Beaux-Arts de Paris in 1965 with a concentration in painting, and later joined the Atelier 17 studio founded by S. W. Hayter (1901–1988) where he began to study etching. This period of his life, during which he gained familiarity with the multicolor printing process utilizing metal plates, was also an important turning point for his artistic creations. The concrete depictions he painted on canvas gradually shifted to explorations of symbol creation and textures. The metal plates used in etching were indeed well suited for recreating the rich and multi-layered textural symbols of traditional Chinese artifacts: the texture of patinated ritual bronzes, the carved designs of lacquerware, and lacquerware inlaid with mother-of-pearl and gemstones. Artworks such as 1966's *La Dévotion*, 1967's *Le Soleil, La Lune,* and *L'etoile,* and the *Gate* painting series that alludes to Chinese couplets (Figures 6-11) sowed the seeds of the symbolic series that would recur in his future creations. Within his circle of Western artist friends, Liao's unique style and presentation emphasized his distinct status as an artist from the East; in particular, tapping into the symbols and vocabulary of temple and folk culture allowed him to unearth creative elements that were rooted in his own cultural roots. As an outsider in a foreign land, this discovery came as a sort of consolation and a way for him to express his nostalgia for home.

Swiss linguist Ferdinand de Saussure (1857–1913), who had a profound influence on the schools of structuralism and deconstruction, was also the founder of semiotics. He believed that structures were not an isolated element, but rather a construct of the juxtapositions among symbols, and the meanings of these symbols were mainly determined by their relationship with other symbols. These relations are what Saussure termed the paradigmatic and syntagmatic axes. The paradigmatic plane refers to the selection of signifiers, which upon selection gains extended meaning when combined with other signifiers.

Liao Shiou-Ping's artworks are diverse in form and cover a range of topic matter. The paradigmatic axis of the semiotic context in his art are mainly derived from Taiwanese folk customs and social protocols, ranging from the axisymmetric designs inherent in the concepts of "*men dang hu dui*" and "double happiness" to the symbols printed on "*jingyi* joss paper" used in religious rituals, which extends to the "feeling of happiness we find in rituals," and all of these paradigms can be connected to the syntagmatic aspect of his art. The following attempts to analyze the *différance* of his creative symbols:

3 Liao Jen-I, "Simple Symbols and Noble Aesthetics: Liao Shiou-Ping, the Versatile Modern Artist," *in Taiwan Fine Art Series 36: Liao Shiou-Ping* (Taipei: Artist Publishing Co., 2018), 17-31.

A. The Axisymmetric Forms of "*Men Dang*" and "*Hu Dui*"

Like an open pair of red double doors, axisymmetric composition has always been a common sight in Liao's creations. This form is indeed relatively rare in Western art, which generally tends towards an asymmetrical sense of balance; it can be described as one half of an object being its exact mirror half, with the objects on both sides of an axis on a two-dimensional surface situated at the same distance away from and in matching positions relative to the axis. This stable symmetry is approved of and praised in traditional Chinese society, and signifies solemnity and dignity, giving off an orderly and courteous air. Through the eyes of a Western artist, such images may be deemed too rigid, lacking in variation, and not lively enough. However, in the Chinese cultural tradition that highly values etiquette, these traits are a symbol of a good upbringing that emphasized the importance of manners and rituals, as well as a guarantee of happiness in life.

Stability and symmetry may have played a part in his axisymmetric arrangements, but perhaps Liao's process of creation was even more intensely influenced by his adolescence and cultivated upbringing. They are an expression of his deepest emotions and memories, the natural images that freely emerged from within in his creative process.

The term "*men dang hu dui*" is an idiom used to describe the Chinese societal concept that successful marriages only occur between people with matching socioeconomic and educational standing. "*Men dang*" originally referred to a pair of stone blocks placed on each side of the main entrance to one's house, used as decoration as well as to "stabilize" the home. Those with meticulous taste would often embellish these stones with various carvings; rounded blocks were used to indicate the residences of military officials, while rectangular stones denoted the homes of civil officials or commoners. "*Hu dui*," then, were protruding brick or wood carvings positioned on door lintels, which were mostly cylindrical, square, or hexagonal in shape. The ends of these shapes would be decorated with patterns or Chinese characters, and they would be used to hang lanterns during festive celebrations at home (Figure 12).

In addition to their decorative and stabilizing properties, "*men dang*" and "*hu dui*" acted also as symbols of a household head's identity, status, and financial situation. "*Men dang hu dui*" thus gradually evolved into a saying to describe whether a marriage is perfectly matched. The axisymmetric designs in Liao's art pieces are reminiscent of him opening those red double doors, continuing in the *différance* of the original symbols. In the process of constructing his own artistic style, Liao borrowed and simultaneously transformed the meaning of these elements; in the process of extracting these visuals, he managed to metamorphose one image into that of another. The symbol *différance* in Liao Shiou-Ping's art has become the distinguishing feature of his unique style (Figures 13 and 14).

B. Consummate Happiness: from Double Happiness to the Mandala

A common Taiwanese saying states, "Red is beautiful; black is unpretentious"—the natural colors of red and black symbolize beauty and a dignified manner. Liao often utilizes these colors, pairing them with the Double Happiness[4] symbol, to form an even number of signs in his works, conjuring emotions of wealth and happiness from within his semiotic context (Figure 15); this runs counter to the Western propensity for the odd number 7 and their common belief in "lucky number 7."[5] Additionally, in Eastern culture, consummate happiness is always depicted through the use of circular, square, or diamond shapes and gradually expanding patterns, observable throughout the spheres of daily life, religion, or cultural tradition. One classic example is the mandala, a symbol with its origins in Buddhist tradition.

A mandala (Sanskrit: मण्डल), literally "circle," has meanings that include "altar," "holy circle," "center," and "magic circle." Originally a small platform built for the practice of yoga in ancient India, it later developed into a drawn symbol which is considered a type of Buddhist sutra painting (Figure 16). Buddhism

4 Double Happiness (囍) is an ornamental design that is composed of two Chinese characters for the word "joy" (喜) as one, and is commonly used in wedding events in China, Taiwan, South Korea, Vietnam, and the Ryuku Islands. It symbolizes the belief that marriage is a happy event for both the families of the bride and groom, and is often shown in red and gold foil as a display of joy.

5 The number 7 has been said to represent a sense of "completeness" in the Bible. It is written in Genesis that God created the world in six days and rested on the seventh, which is why there are seven days in a week, and also one reason why people would view 7 as a lucky number. Another theory links "lucky 7" to a game played in casinos, where rolling a seven from a pair of dice was a win, and thus it became a symbol of gambler's luck and being lucky.

adopted the Indian practice of using these images as an aid in meditation, resulting in many different forms of mandala. They represent the concentration of energy around a center, which gradually spreads in concentric circles to the outer layers. These harmonious, orderly arrangements embody an energy similar to that of the continuous, outward movement of ripples on water.

When asked about mandalas, people will generally envision something that resembles the Tibetan Buddhist *thangka*, which are "magic circles" depicting a central figure surrounded by other images in a symmetrical design.

Setting aside religious thinking, even psychologist Carl Jung thought the mandala to symbolize a central goal or a rebalancing of the psyche towards a central point, which could be conducted in the shape of a circle, square, or diamond that allowed growth in all directions. The ego, as the mediator of the psyche, encompasses a relatively stable and evolved state. Jung considered the collective subconscious/unconscious to be the most intense part of one's personality, a prototype comprised of the accumulated experiences of our human ancestors. Deep within our individual consciousnesses lie an instinctive mind that was not a product of our daily life experiences, but rather attains mental balance and order through symbols.

Confucian text *The Great Learning* talks of the process of "determination-calmness-tranquility-deliberation-attainment" (定靜安慮得), which refers to an excerpt that offers wisdom for how to attain a peaceful life and seemingly shares points with the aforementioned theories on self-reflection and spiritual enlightenment. These teachings were ingested by Liao to eventually become the foundations of his artworks (Figures 17-19).

Modern Taiwanese art has its origins in the 1960s: around the end of the '50s and the beginning of the '60s, the popularity of modernism grew, and discussions surrounding the "introduction of Western techniques into Chinese paintings" and "the combination of Chinese and Western techniques or elements" spurred the vigorous development of the local modern art movement. Artist groups such as the Fifth Moon Group, Ton Fan Group, and Today Art Group sparked a modernist painting trend. The publication of Hsu Fu-Kuan's article "The Direction of Modern Art" in 1961 and the debates on modern painting involving Liu Kuosung and Yu Jun-Zhi only further boosted the growth of the Taiwanese modern art scene.

In addition to their emphasis on modernism, the Taiwanese painters of this period commonly drew depictions of consummate happiness through the adoption of circular, square, or diamond shapes; employing mandala-esque designs; and using blacks and reds. Indeed, this is an interesting phenomenon observable even the simple and uncomplicated creations of Liu Kuosung.[6]

C. The *Différance* of *Jingyi* Joss Paper's Ritualistic Use

The appearance of *jingyi joss* paper symbols in Liao's work began during his period of studies in France (1964–1968), first in his paintings and etchings, then silkscreen prints. Due to the convenience of silkscreen printing and the assistance of collaborating printing factories, these artworks are the most prevalent and most abundant in number. They also echo the modernist belief that art should represent everyday life and the general public.

The earliest instance of Liao's explorations into the *différance* of *jingyi* joss paper symbolism occurred over the course of his time studying and living abroad. He constantly reminisced about his life and hometown in Taiwan: during his youth, apart from the plumes of smokey incense that enveloped him during his mother and his visits to the nearby Lungshan Temple, he retained strong impressions of the high-spirited *Zhongyuan Pudu* ("Ghost Festival")[7] festivities that occurred in the seventh month of the lunar year as well as the minutiæ of the rituals worshipping "good brothers," or ghosts. Once the offerings have been

6 Wang Teh-Yu David, "Circular Imagery in Liu Kuosung's Paintings," in *An Exhibition of the Art of Liu Kuosung: Selected Writings on the Art of Liu Kuosung*, ed. Lee Chun-Yi (Taipei: National Museum of History, 1996), 174-192. Circles were also common in the paintings of other artists of the period, such as Chin Sung, Ho Kan, Chen Ting-Shih, and Lee Shi-Chi.

7 The emergence of the *Zhongyuan* Festival ("Ghost Festival") would not have been later than the Han Dynasty. It was originally a ritual for farmers to worship the gods of the fields and land in late summer to early autumn, where they would pray for a good harvest and thank the earth. It was customary to worship ancestors during the same season, so families began to worship their ancestors during every *Zhongyuan* Festival, performing rituals when offering sacrifices. With the aggregation of the three schools of Buddhist, Confucian, and Taoist thought in the Song Dynasty, a number of related worship events appeared throughout East Asia, including: the Taoist *Zhongyuan* Festival to worship the dead; the Buddhist *Yulanpen* Festival to appease hungry ghosts; Confucian ancestral worship; plus other local shamanic religious rituals including China's Wuism, Japanese Shintoism, Korean shamanism, and Ryukyu Shintoism. See "Ghost Festival" on *Wikipedia*, accessed July 21, 2022, https://bit.ly/3ORnow6.

placed on the table but before praying with incense, there is a very distinct step in the ceremony that involves the burning of *jingyi joss* paper (Figure 20).

According to the *Dictionary of Taiwan Folk Artifacts, jingyi or gengyi* are a type of joss paper (paper money) burned as offerings to "good brothers" during the *Zhongyuan* Festival. In Northern and Central Taiwan, *jingyi* are significantly bigger in size, measuring roughly 30cm x 10cm; the kind used in Southern Taiwan are small pieces of yellow paper stamped with green images. Printed on the *jingyi* paper are daily necessities like men's and women's clothes (men have shirts and pants, while women have shirts and long skirts), shoes, combs, scissors, mirrors, and fans. They are generally used during *baimenkou* rituals (placing offerings in front of one's house) held every first and fifteenth or every second and sixteenth of the lunar month, or during *Zhongyuan* festivities when worshipping "good brothers."[8]

The *Zhongyuan* Festival ("Ghost Festival") initially began as a custom of farmers who offered sacrifices to the gods of the fields and land in late summer to early autumn, ultimately becoming a ritual for all households to participate in to offer sacrifices to the spirits of their ancestors and the deceased; this tradition has brought about a series of worshipping events that greatly highlight adherence to protocol. After the constant warping and reshaping of the meanings of these ritual components, they have already taken on different interpretations.

Rituals, in psychoanalytic diction, can be described as "the formation of a fixed pattern or compulsive repetition of actions." However, rituals can also play an important factor in the generation of ideas and achievement of goals. They are the stringing together of actions underneath a single concept to form a common vision; the so-called sense of ritual is not necessarily a concrete, material behavior, but more of a serious attitude. Rituals may not necessarily bring luck, but the feeling of self-consciousness that stems from the sense of ritual may cause people to begin to rethink their values and purpose, resulting in increased levels of self-confidence and happiness. A ritual is a predetermined set of repetitive, symbolic action sequences that lack immediate utility. First, it consists of acts that occur in a fixed succession, one after the other, and is characterized by form and repetition; second, these acts have a symbolic meaning; and lastly, these behaviors often have no apparent purpose. However, ritualistic practices help bring a degree of predictability to an uncertain future by buffering the anxiety that accompanies unpredictability. In some cases, even just observing rituals and not actively participating can provide comfort.

As the times change across generations, alternative uses of joss paper have been ritualized, and it has also appeared at various artistic exhibitions or performances. An example of this is in the Taiwanese heavy metal music community: at the end of concerts of the band Chthonic, fans will routinely throw large amounts of joss paper into the air as a way of paying homage to the ancestors and spirits described in the band's songs.

The action of scattering joss paper during Chthonic's performances began to appear after they released a single in 1998. Since then, it has gradually become a staple at their shows, and scenes of fluttering joss paper have also become a part of the tradition of their concerts. After twenty years, some veteran music fans have also adopted the behavior at the performances of other Taiwanese metal bands as a way of expressing how emotionally invested and intoxicated they are by the music[9].

Yet, the ritualization of the *jingyi* joss paper symbol in Liao's works may be closer to the concept of praying for blessings and good fortune embodied by Tibetan prayer flags. These five-colored flags are ubiquitous throughout Tibet, their mantra-decorated fabric flying in the wind, just like Tibetan landscape art.

8 See "*Jingyi* joss paper (*gengyi*)," *Dictionary of Taiwan Folk Artifacts,* Taiwan Historia, accessed July 21, 2022, https://dict.th.gov.tw/term/view/1406; "Instructions for the Use *Zhongyuan Pudu* Essential *Gengyi,*" accessed July 22, 2022, https://bit.ly/3oNshfe. In Minnan, Taiwanese, Malay-Chinese, and Chinese Singaporean circles, "good brothers" is a term used to refer to spirits of the dead with no further descendants to worship them. *Gengyi* joss paper are burned at two points during the *Zhongyuan Pudu* ritual: once before eating (after offering incense) and once after eating (at the end of the ritual). Burning several stacks of *gengyi* printed with clothing before worshipping "good brothers" symbolizes asking the ghosts to groom and dress up before enjoying their meal. On the one hand, it isn't convenient for us to invite them into our homes, and on the other, our door gods wouldn't allow ghosts to enter our homes anyway, which is why we participate in *baimenkou* (making offerings in front of our homes). Burning gengyi before eating also serves as an invitation, so one needs to take care to not burn too much and to prepare an appropriate amount of offerings so as not to offend any ghosts who were unable to grab a bite to eat. Remaining *gengyi* can be burned along with any silver joss paper after *Pudu* is finished. These act as takeaway gifts for the "good brothers," providing them with a year's worth of clothes and necessities. All *gengyi* can be burned once the food offering ritual is complete.

9 Hsiang Yu Mark Feng, "Why scatter joss paper? A discussion beginning from Burning Island's 2018 Breath of Fire concert," Medium, July 9, 2019, accessed July 26, 2022, https://bit.ly/3ONcwza.

Prayer flags are said to carry good wishes and generally represent blessings and prayer[10] (Figure 21).

Research on human rituals was originated by Polish-British anthropologist Bronislaw Malinowski (1884–1942), who believed that belief and adherence to rituals could help people cope with uncertainty and danger in their work. While visiting the Trobriand Islands of Papua New Guinea in the early 20th century, the anthropologist—known as the father of ethnography—documented a long list of rituals the islanders performed before heading out to sea. These actions were the islanders' way of dealing with the unpredictability of the Pacific Ocean.[11]

From the circular, square, and diamond shapes, to the axisymmetric form of the mandala, and the use of black and red, Liao began his construction of his own semiotic language within his artistic context. The paradigmatic development of his use of the symbol of *jingyi* joss paper, a necessity in Taiwanese folk religion, evolved into a system of visual symbols that can be further interpreted as a "re-ritualization" of the "happiness in rituals." The original meaning of the *jingyi* symbol within rituals gradually underwent a transformation, dissipating in the continuous outward expansion of its essence; as its meaning endured an endless cycle of generation, transition, and disappearance, it even lost its initial meaning, leaving it at last as a symbol of blessings and prayer. Harnessing his own personal experiences to face life and its obstacles head on, Liao Shiou-Ping's love for his hometown and its people have profoundly shaped the semiotic context at the core of his creations (Figures 22, 23, 24, and 25).

IV. Conclusion

When referring to "Master of Pop Art" Andy Warhol, most people would probably not choose to descibe him as "an outstanding modern printmaker;" in the same vein, it is unfair of us to refer to Liao Shiou-Ping as just the "pioneer of modern printmaking in Taiwan," or even the "Father of Taiwanese Modern Printmaking." Of course, it is undisputable fact that Liao spared no effort in the promotion of printmaking, achieving fruitful results; however, the value of Liao's art should not stop there. Stretching from his time overseas through his return to Taipei, his lifelong investments in and the development of the technique, as well as his overall artistic achievements and standing within the art world, should garner more attention and praise than they do now.

With the formation of the global village after World War II, human interaction has grown easier and more frequent. Modern art advocates for art to be closer to daily life, and silkscreen printing is one of the most prominent ways to popularize art. If the greatest value of contemporary artworks no longer lies in the physical creations but rather the recognition of one's creative concept and unique style, then Liao's explorations of axisymmetric composition, taken from the Taiwanese cultural concept of "*men dang hu dui*," and the religious symbol *jingyi* have opened up an entire world of personal artistic symbols. The formation and development of his artistic concept is comprehensive and of contemporary significance, and is indeed worthy of appreciation and respect.

Liao Shiou-Ping's solo exhibition *Return: The Semiotic Context of Liao Shiou-Ping's Works* will be held in September 2022 at the Bo'ai Gallery in National Dr. Sun Yat-Sen Memorial Hall. Along with a retrospective of his classic masterpieces, Liao will also be displaying a series of woodblock prints that incorporate *jingyi* symbols and combine traditional woodblock techniques with hand-drawn ink wash painting into mixed media creations. These artworks showcase the subtle interactions between the more-accurate printing and less-controllable art of ink wash. It's almost like the artist's way of declaring to the world that, even nearing 90, Liao has no plans to slow down anytime soon!

10 Tibetan prayer flags come in five colors—white, yellow, red, green, and blue—each with different meanings: blue represents the sky, red represents fire, white represents the clouds, green represents water, and yellow represents the earth. The prayer flag has its origins in the worshipping of animal souls in primitive sacrificial culture. Initially, they were just pieces of animal pelt hung up on branches. The center of these flags depicts a *lung ta* (powerful or strong house) carrying three flaming jewels which represent the Buddha, the Dharma, and the Sangha on its back. Surrounding the *lung ta* are animals such as the bird, the dragon, the lion, and the tiger. Prayer flags also represent the *Wuxing* ("Five Phases," consisting of fire, water, wood, metal, and earth), and acknowledge that all beings are part of a continuous ongoing cycle.

11 Johnson, Karan, "The surprising power of daily rituals," *BBC News Chinese*, October 25, 2021, accessed July 23, 2022, https://www.bbc.com/zhongwen/trad/world-58844461. Malinowski established an objective approach to making ethnographic records of his fieldwork, and pioneered the earliest social anthropology courses.
"When the anthropologist Bronislaw Malinowski visited the Trobriand Islands in Papua New Guinea in the early 20th Century, he noted the elaborate preparations fishermen would make before setting out to sea. They would carefully paint their canoes with black, red and white paint, chanting spells as they did so. The vessel would be struck with wooden sticks, the bows stained with red ochre and crew members would adorn their arms with shells. Malinowski recorded a long list of ceremonies and rituals the islanders would perform before venturing out into the open sea."

圖版
Plates

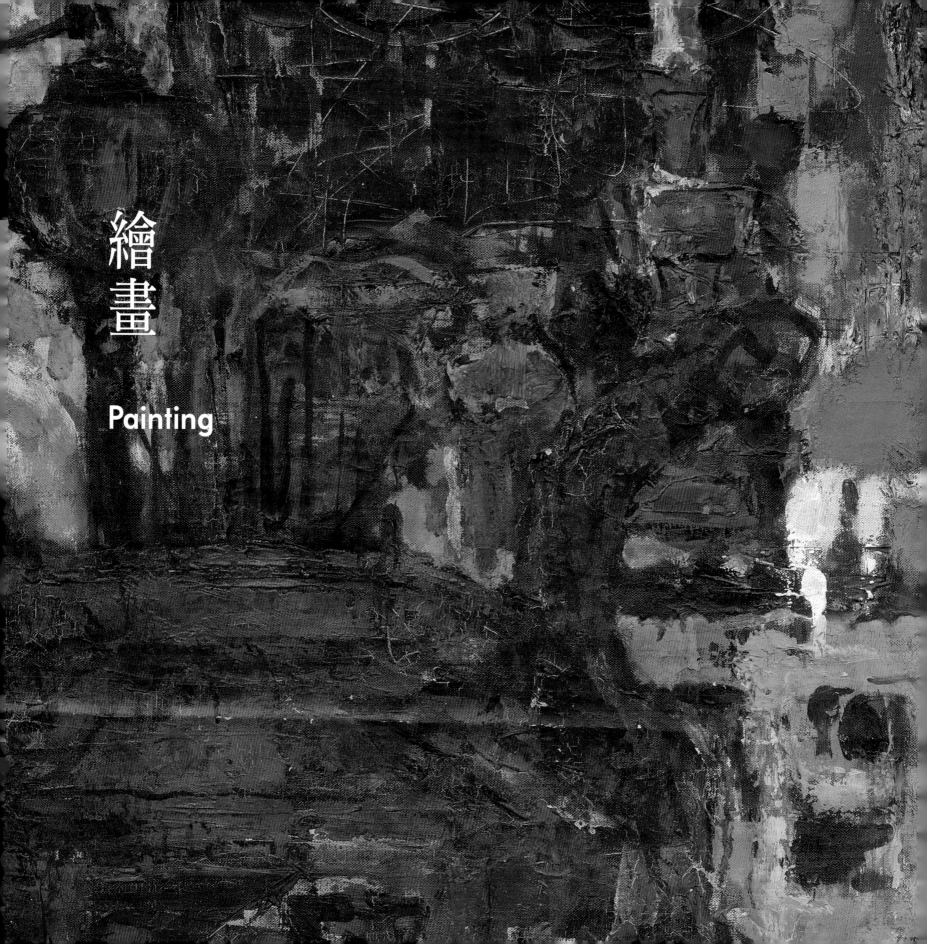

繪畫

Painting

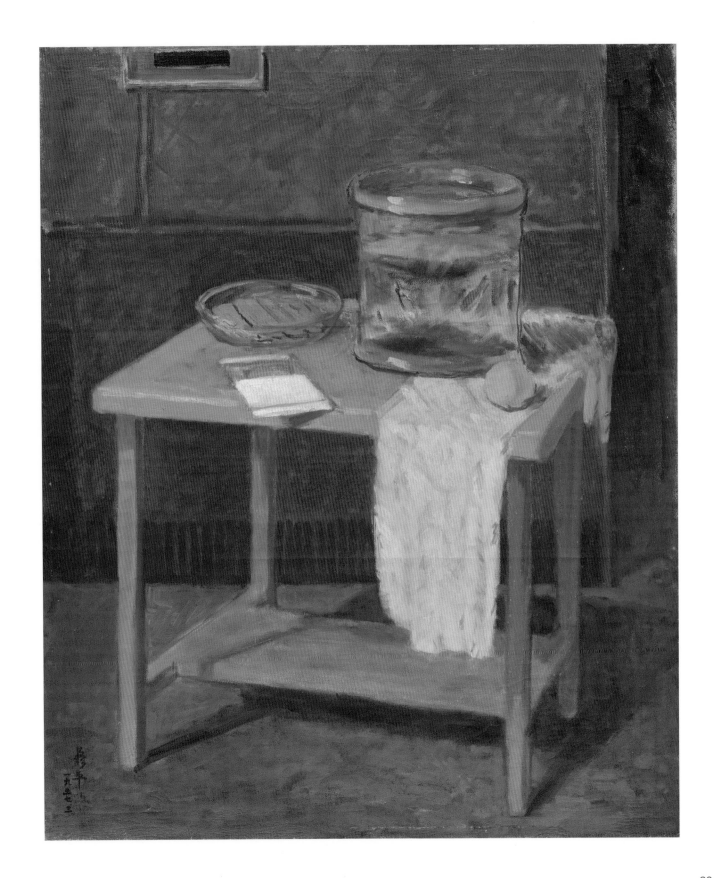

魚缸 *Fish Tank*

1957
油彩、畫布 Oil on canvas
71×61 cm

植物園 *Botanical Garden*

1957
油彩、畫布 Oil on canvas
50.5×61 cm

陽台 *A Balcony*

1957
油彩、畫布 Oil on canvas
73.5×61 cm

江邊 *Riverbank*

1959
油彩、畫布 Oil on canvas
116×160 cm

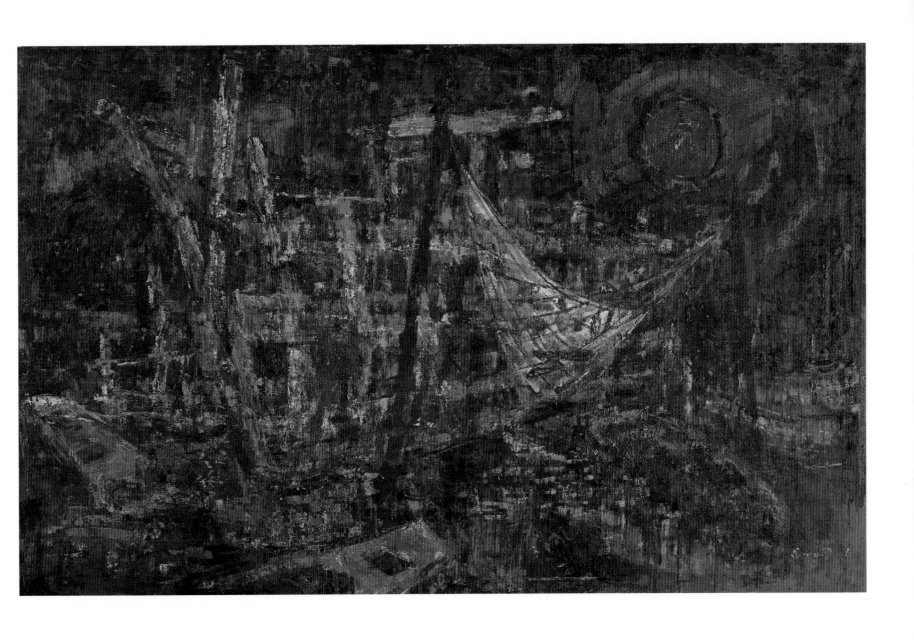

落日（夕照）*Dusk*

1959
油彩、畫布 Oil on canvas
90×144 cm

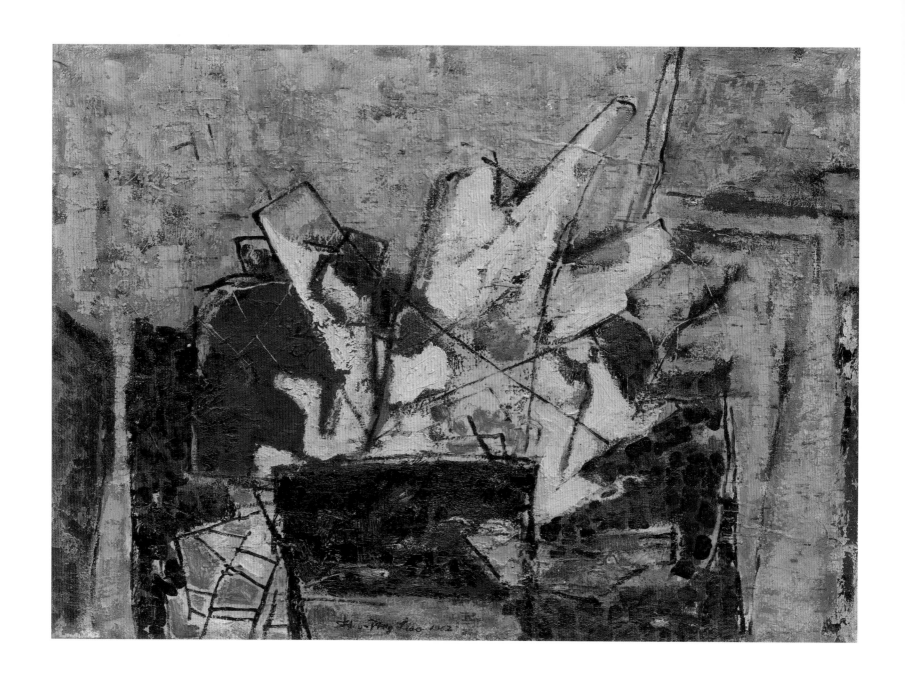

桌上靜物 *Still Life on a Table*

1962
油彩、畫布 Oil on canvas
67×93 cm

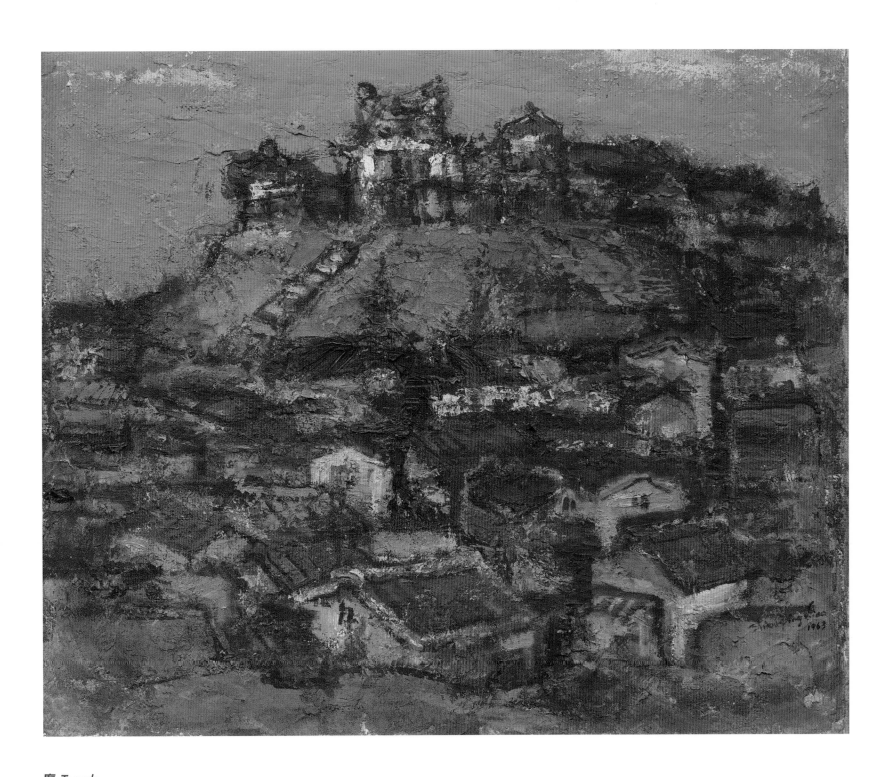

廟 *Temple*

1963
油彩、畫布 Oil on canvas
50×60.5 cm

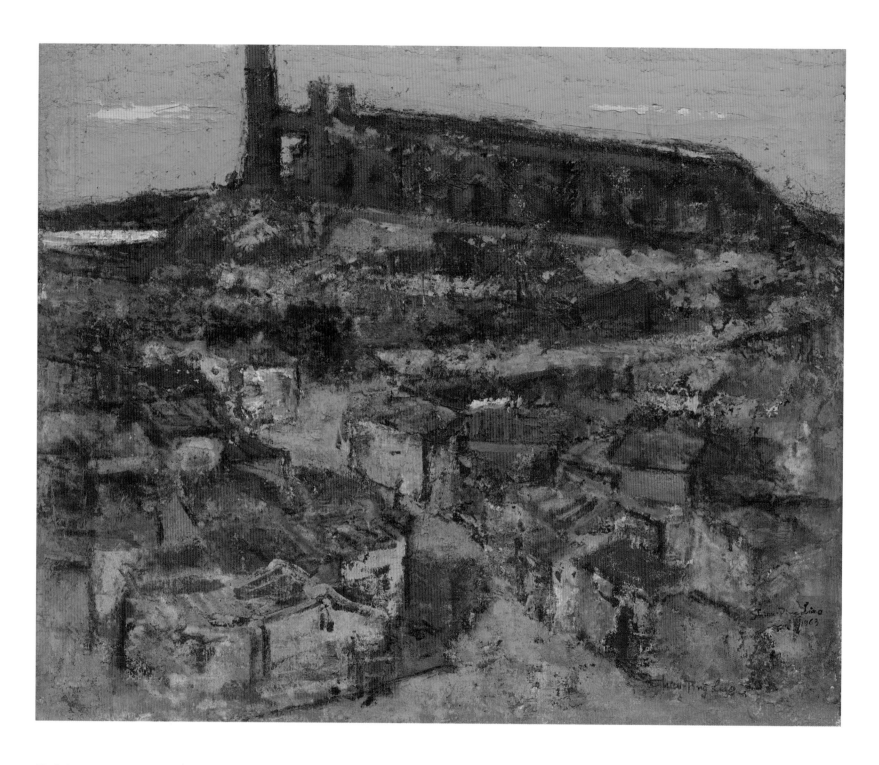

燒磚廠 *Brickyard*

1963

油彩、畫布 Oil on canvas

53×65 cm

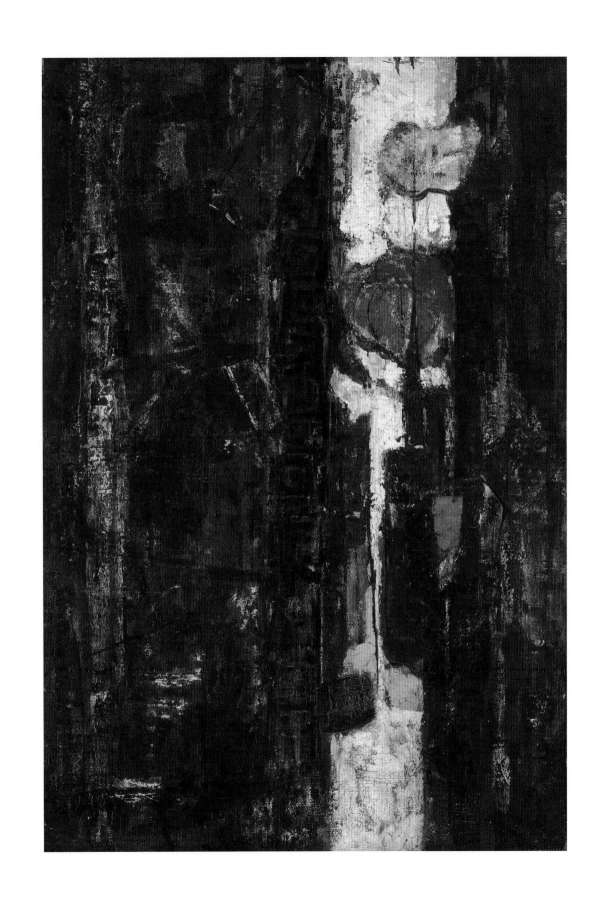

古蹟 *Relics*

1964
油彩、畫布 Oil on canvas
128×88 cm

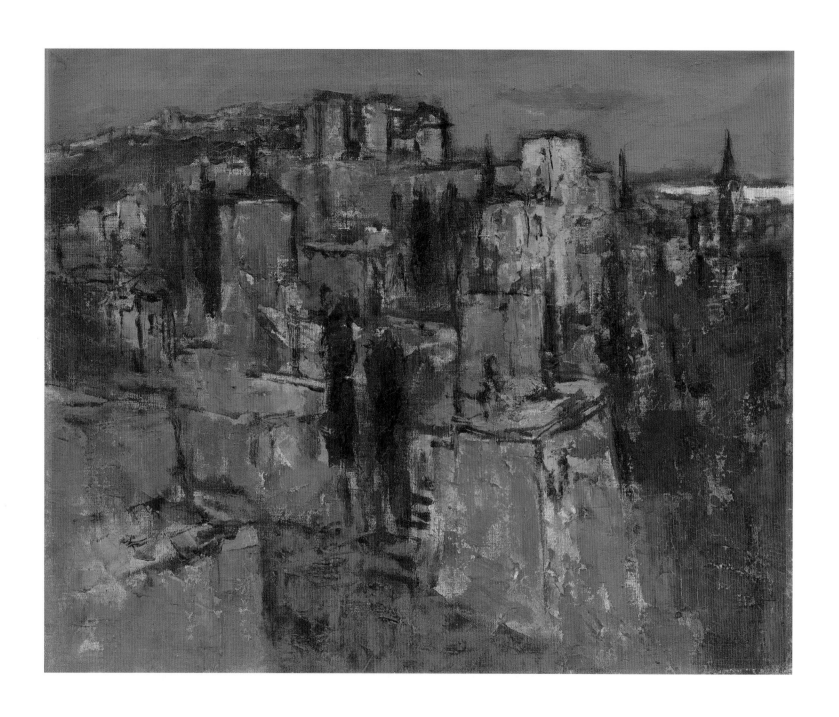

西班牙古城 *Malaga*

1965
油彩、畫布 Oil on canvas
58×72 cm

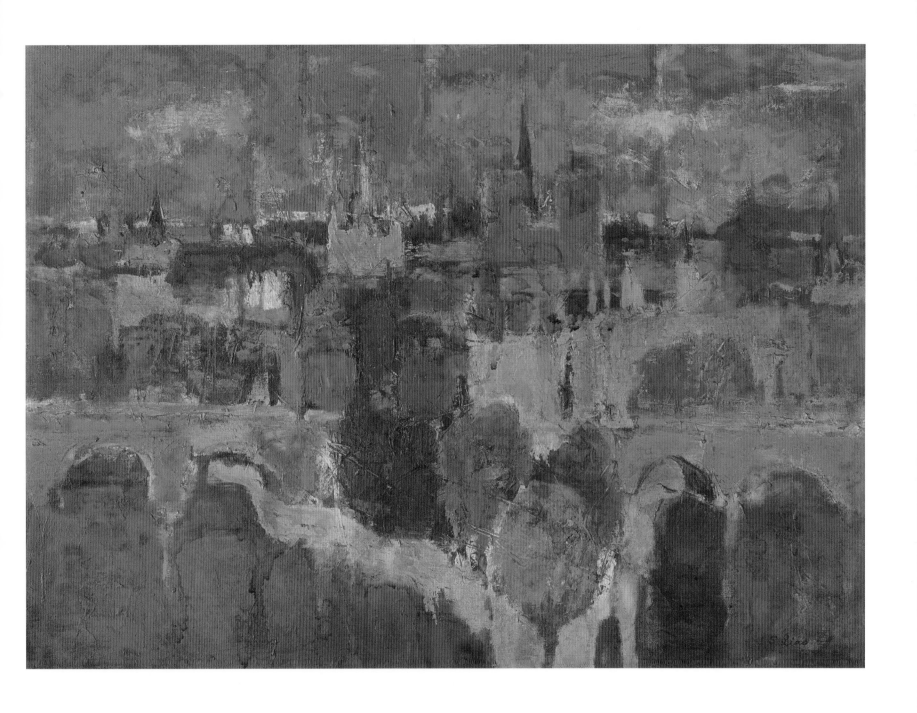

巴黎街景 *Street, Paris*

1965-66
油彩、畫布 Oil on canvas
71×99 cm

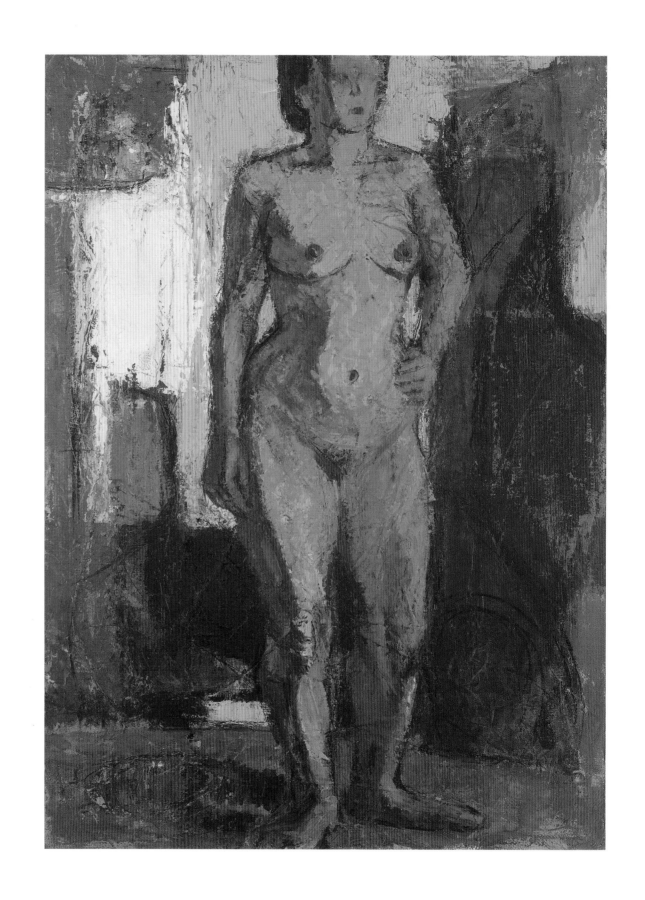

人體習作（三）*Nude III*

1963
油彩、畫布 Oil on canvas
98×72 cm

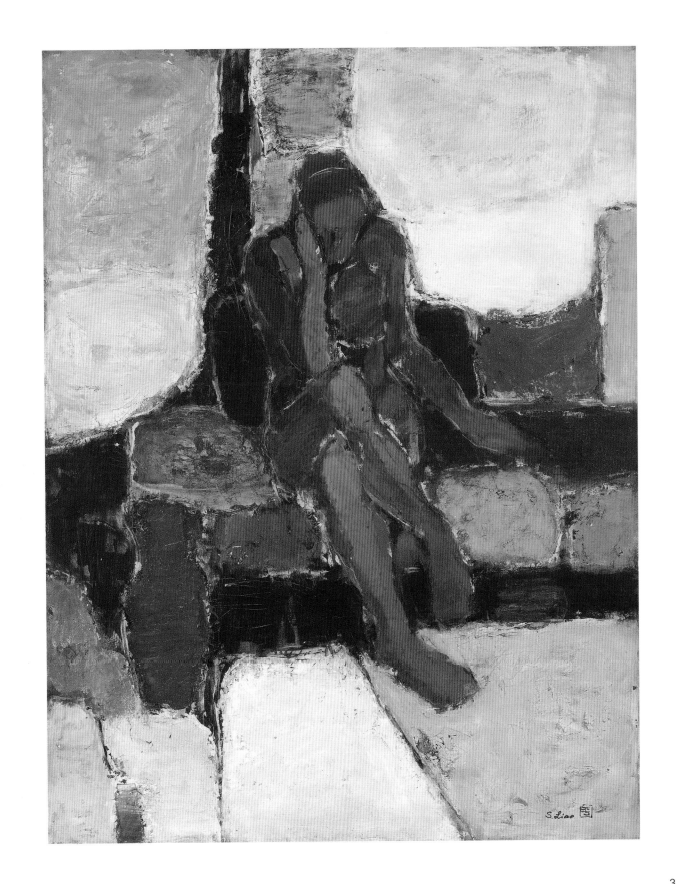

裸女 A Nude A

1965
油彩、畫布 Oil on canvas
115×88 cm

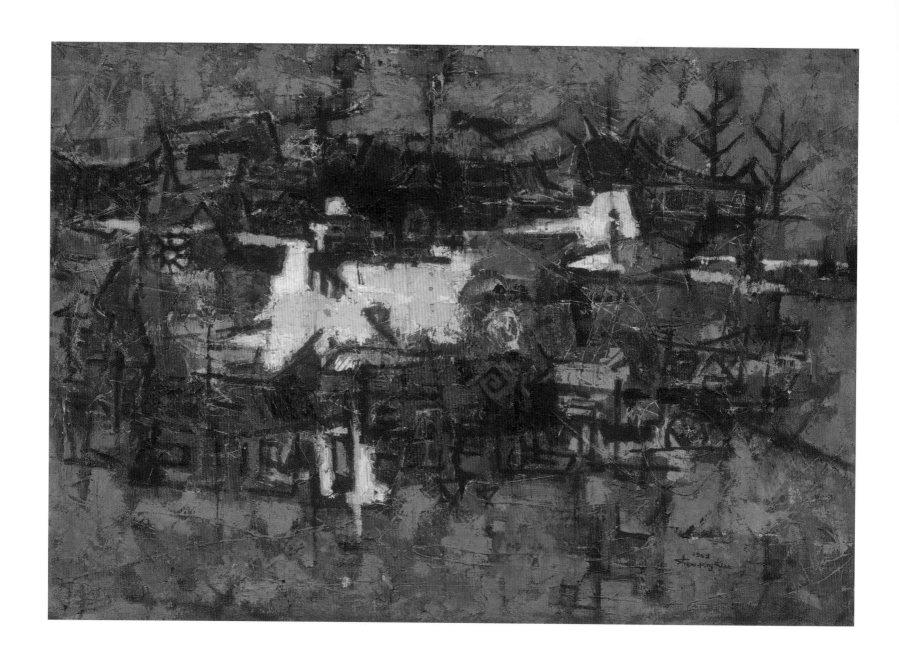

鄉村 *Village*

1963
油彩、畫布 Oil on canvas
130×162 cm
私人收藏 Private Collection

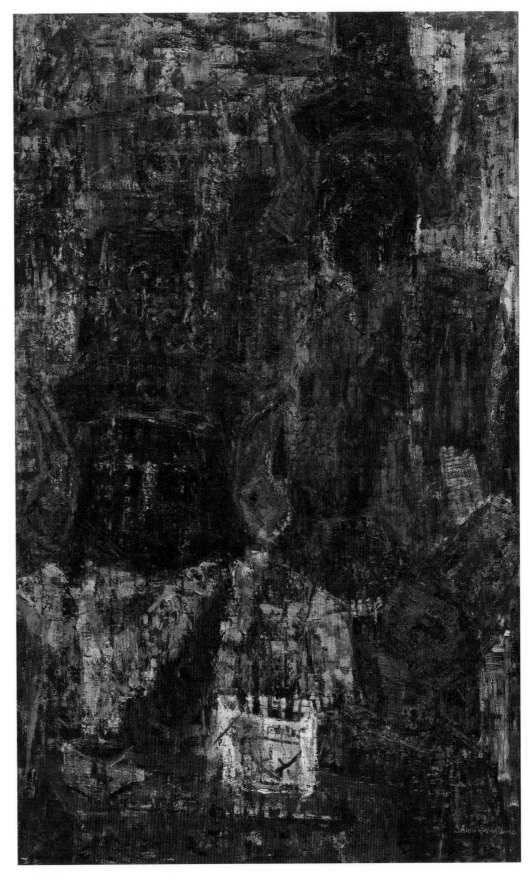

七爺八爺 *The Tall God and The Pudgy God*

1959
油彩、畫布 Oil on canvas
145×97 cm

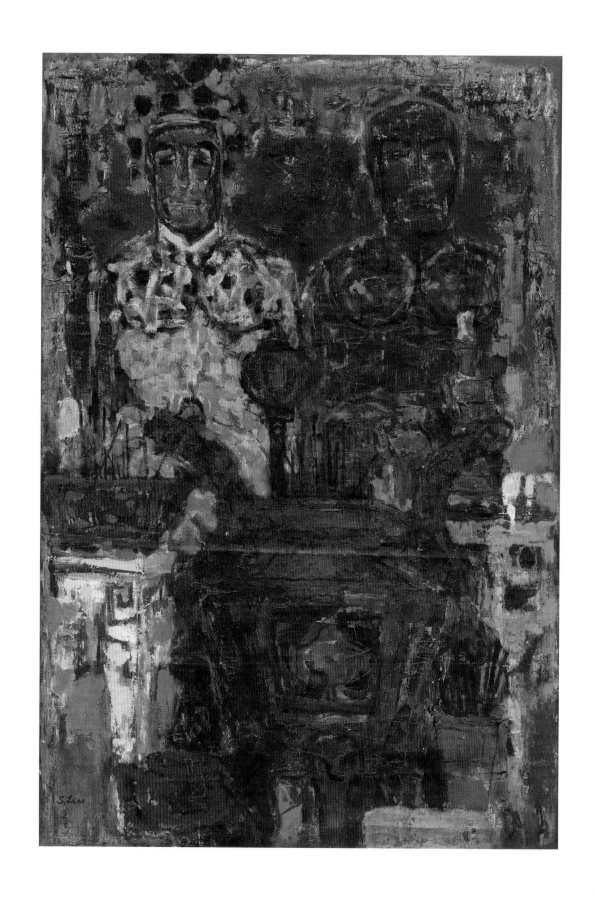

廟神（三） *Guardian of the Temple III*

1964
油彩、畫布 Oil on canvas
130×89 cm

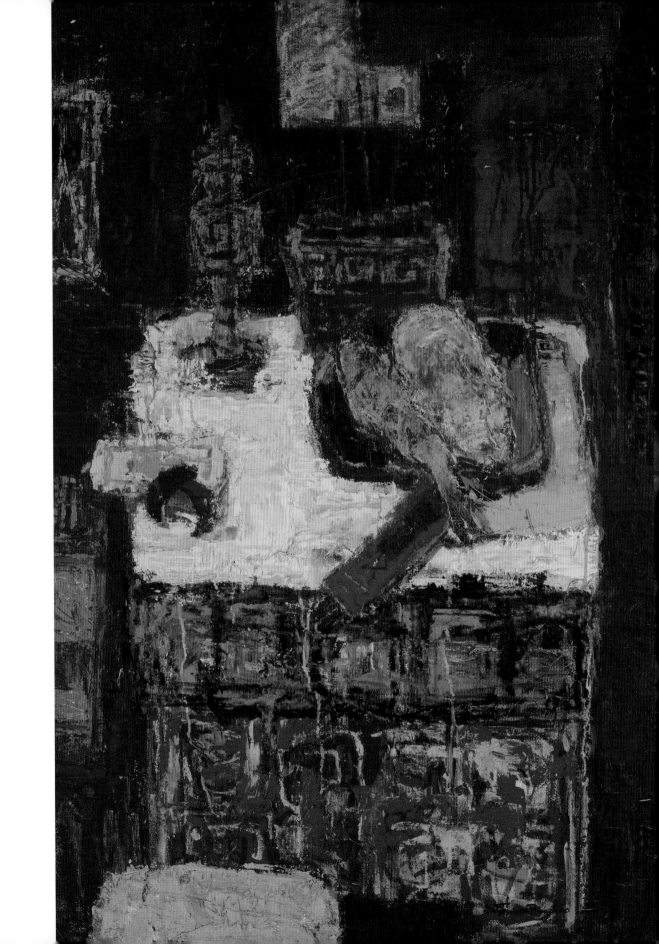

祭神 *Worship*

1963
油彩、畫布 Oil on canvas
128×87 cm

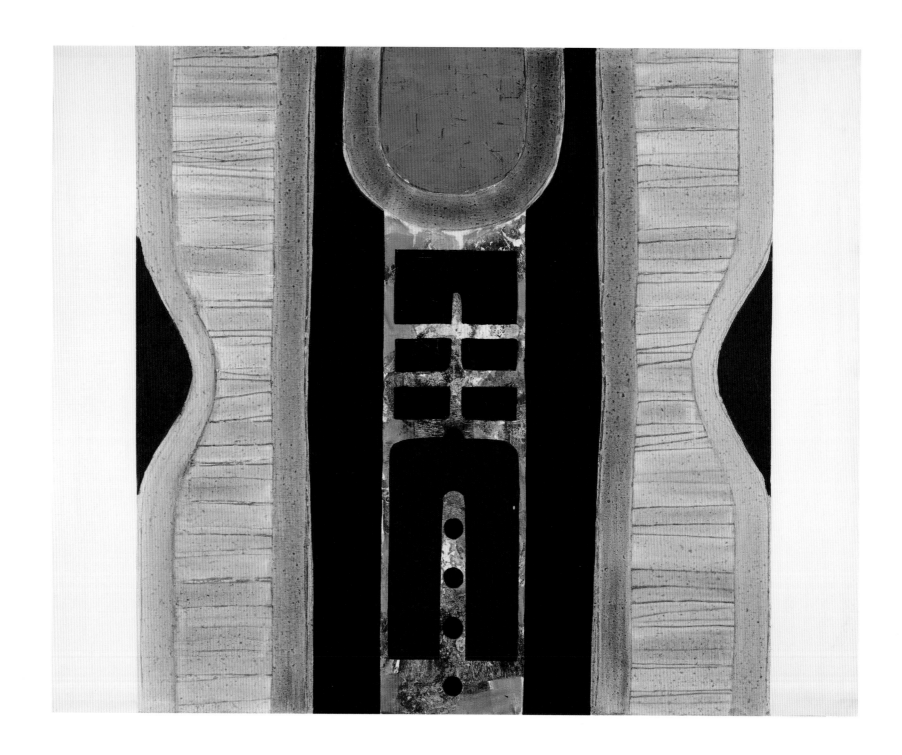

門 *Gate*

1966
油彩、金箔、畫布 Oil and gold leaf on canvas
117×149 cm

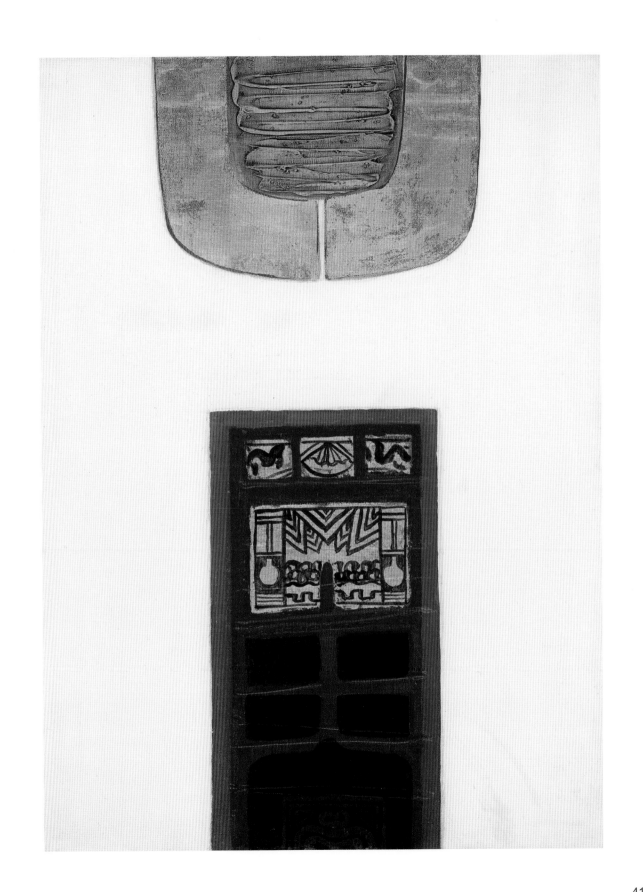

門之連作 *Gate*

1966
油彩、金箔、畫布
Oil and gold leaf on canvas
72.3×53.59 cm

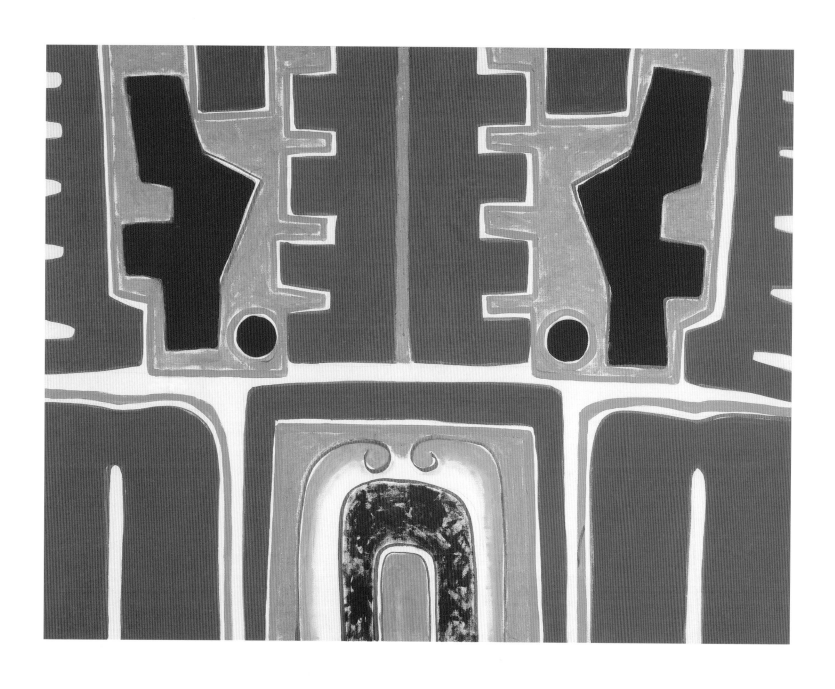

門之連作 #66-10 *Gate # 66-10*

1966
油彩、畫布 Oil on canvas
89×115 cm

東方之門（二） *Gate of Oriental II*

1974-1980
壓克力、金箔、木板浮雕
Acrylic and gold leaf on wood
120×90 cm
私人收藏 Private Collection

福 *Fortune*

2015

壓克力、金箔、畫布 Acrylic and gold leaf on canvas

120×120 cm

人生四季（二） *Life's Seasons II*

2017
壓克力 . 金箔 . 畫布 Acrylic and gold leaf on canvas
53×45 cm×2

富臨門（十） *Gate of Wealth X*

2017
壓克力、金箔、畫布 Acrylic and gold leaf on canvas
162×300cm

福門 20-G *Gate of Fortune 20-G*

2020
壓克力、金箔、畫布 Acrylic and gold leaf on canvas
50×50 cm×4

迎福門（一）*Gate of Prosperity I*

2010
壓克力、金箔、畫布
Acrylic and gold leaf on canvas
162×422 cm

富臨門（十九）*Gate of Wealth XIX*

2022
壓克力、金箔、畫布
Acrylic and gold leaf on canvas
120×120cm×3

六福之門 *Gate of Fortune*

2020
壓克力、金箔、畫布 Acrylic and gold leaf on canvas
150×30 cm×7

福門 20-H *Gate of Fortune 20-H*

2020
壓克力、銀箔、畫布 Acrylic and silver leaf on canvas
120×259 cm

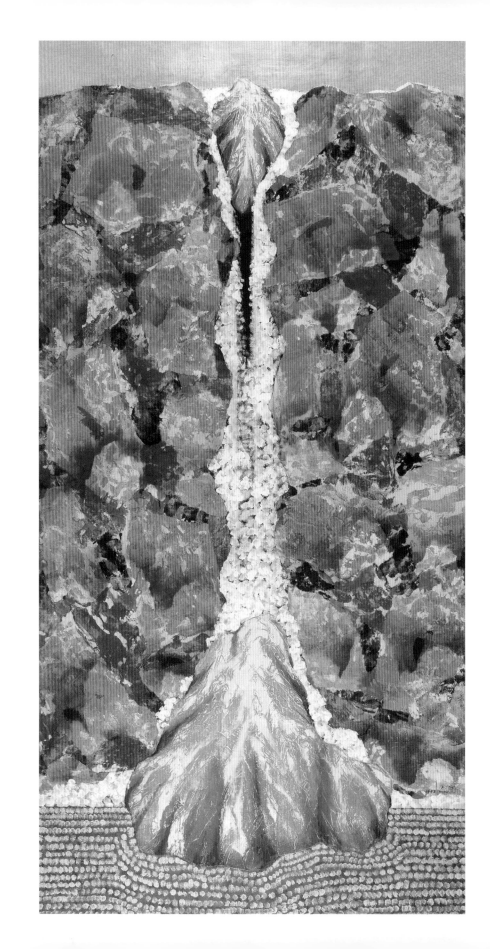

秋泉 *Waterfall in Autumn*

1992
油彩、金箔、畫布 Oil and gold leaf on canvas
181×91 cm

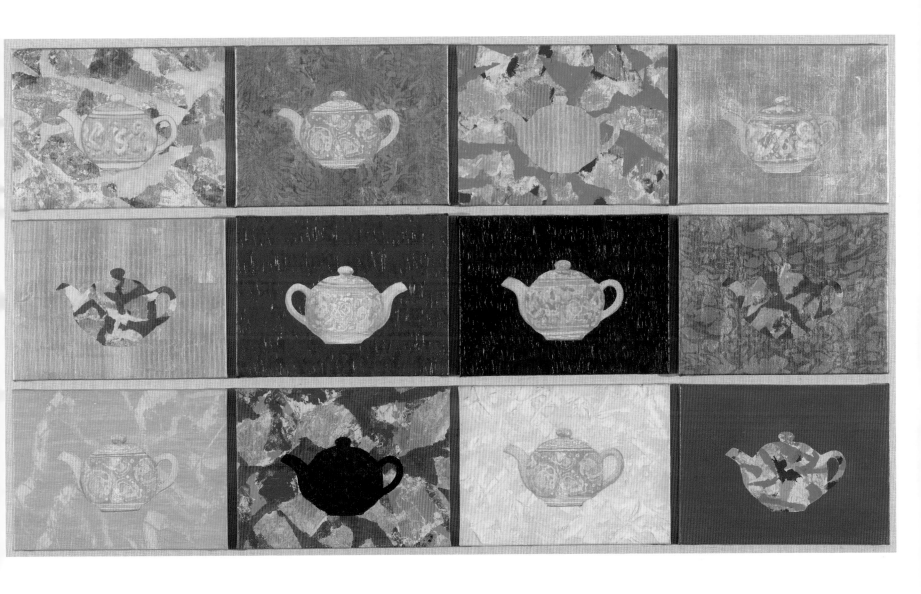

四季之敘 *# 96-1 Seasonal Chat # 96-1*

1995
油彩、混合媒材 Oil and mixed media on canvas
74×136 cm

安逸 *Cozy*

2021
壓克力、油墨、油漆、金箔、畫布 Acrylic, ink, paint and gold leaf on canvas
50×50cm×4
私人收藏 Private Collection

金海岸 A B *Golden Seacoast A B*

2016
壓克力、金箔、畫布 Acrylic and gold leaf on canvas
80×53cm×2
私人收藏 Private Collection

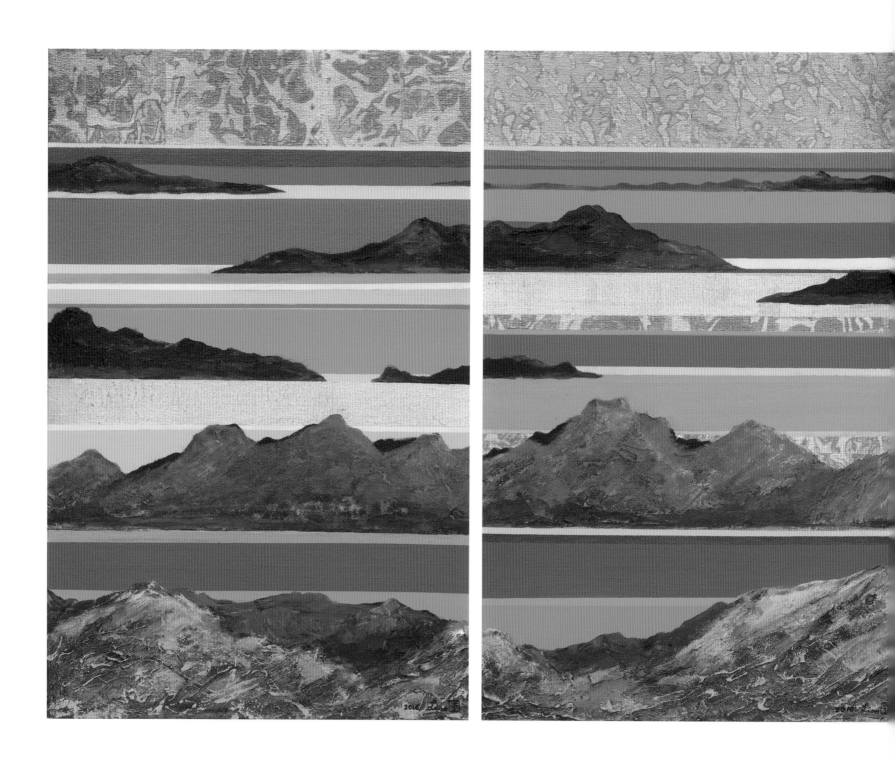

海岸（一）（二）（三）（四） *Seacoast I II III IV*

2016
壓克力、金箔、畫布 Acrylic and gold leaf on canvas
80×53cm×4

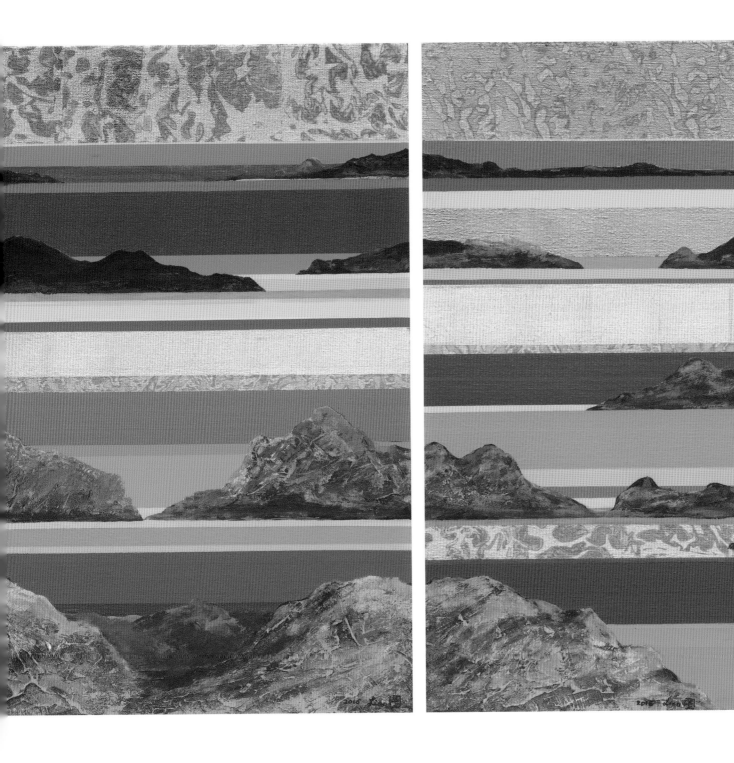

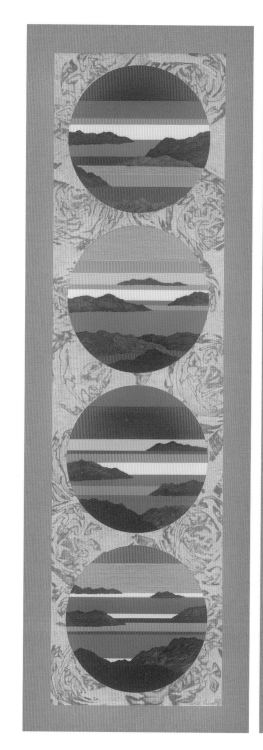
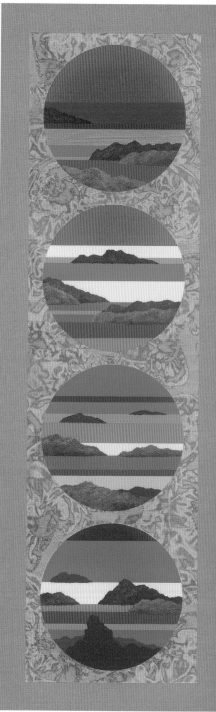

四季海岸（二） *Seasons on the Coast II*

2021

壓克力、金箔、畫布 Acrylic and gold leaf on canvas

120×40cm×6

水墨

Ink and Color

捉影（七）*Drawing-7*

2018
墨、紙 Ink on paper
176×84 cm

捉影（八） *Drawing-8*

2018
墨、紙 Ink on paper
176×84 cm

墨（一）Ink 1

2018
墨、紙 Ink on paper
121×68.5 cm

墨（六）Ink 6

2018
墨、紙 Ink on paper
145.5×79.5 cm

墨（十）*Ink 10*

2022
墨、紙 Ink on paper
164×71 cm×6

版畫

Printmaking

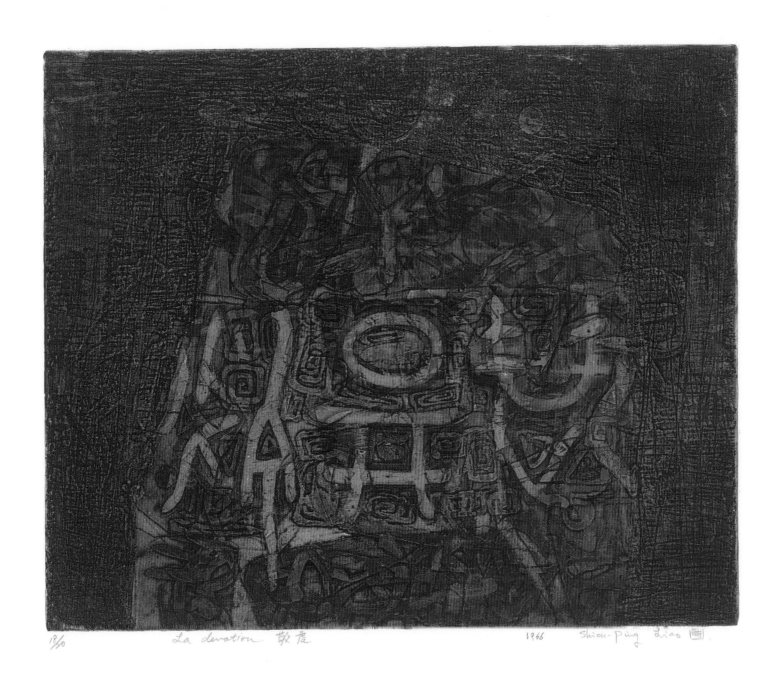

敬虔 *La Dévotion*

1966
蝕刻金屬版 Etching
39×45 cm

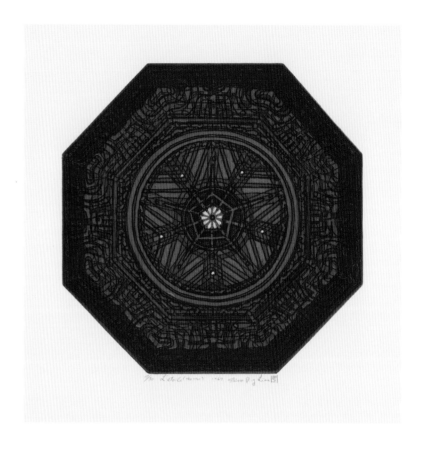

懷古 *Nostalgia*

1966
蝕刻金屬版 Etching, Aquatint
44×25 cm

星星 *L'etoile*

1967
蝕刻金屬版 Etching
46×46 cm

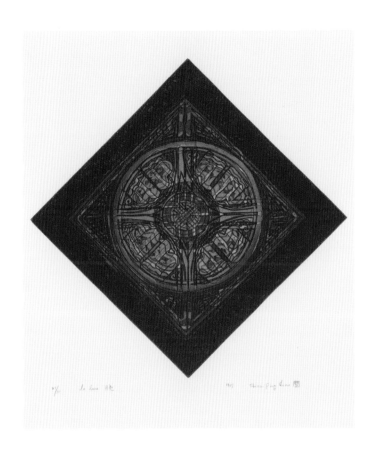

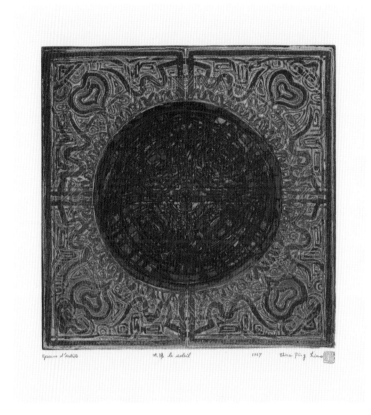

月亮 *La Lune*

1967
蝕刻金屬版 Etching
60×60 cm

太陽 *Le Soleil*

1967
蝕刻金屬版 Etching
48×48 cm

陰陽 *Yin and Yang*

1970
蝕刻金屬版 Etching, Aquatint
59×44.5 cm

東方節 *Oriental Festival*

1970
蝕刻金屬版 Etching, Aquatint
60×45 cm

嚮往自然 *Longing for Nature*

1974
絲網版 Silkscreen
55.7×69 cm
私人收藏 Private Collection

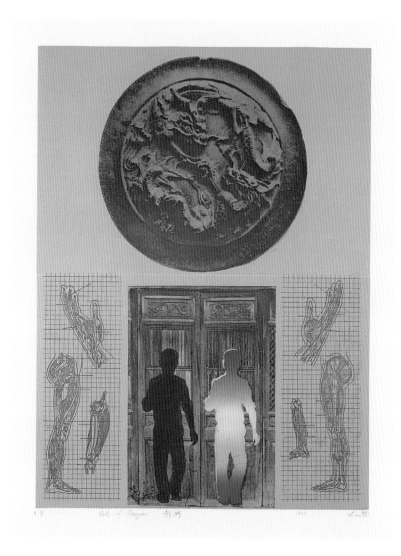

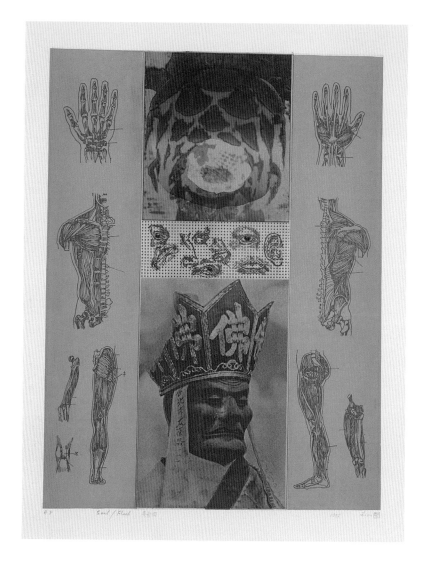

龍門 *Gate of Dragon*

1975
蝕刻金屬版 Etching
60×45 cm

靈與肉 *Soul / Flesh*

1975
蝕刻金屬版 Etching
60×45 cm

靜物 *Still Life*

1976
絲網版 Silkscreen
77×51 cm

山 湖 竹 I II III *Mountains/Lake/ Bamboo I II III*

1987
絲網版、紙凹版 Silkscreen, collagraph
44×58 cm×3

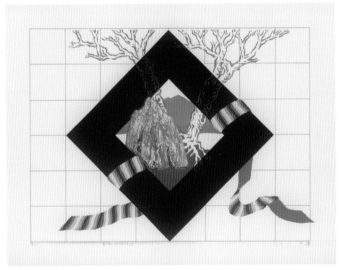
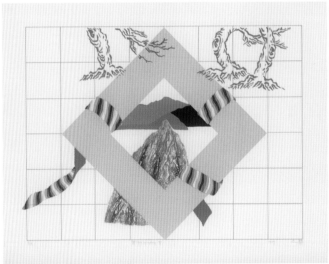

窗（春／夏／秋／冬） *Window I II III IV*

1989
絲網版、紙凹版 Silkscreen, collagraph
43×58 cm×4

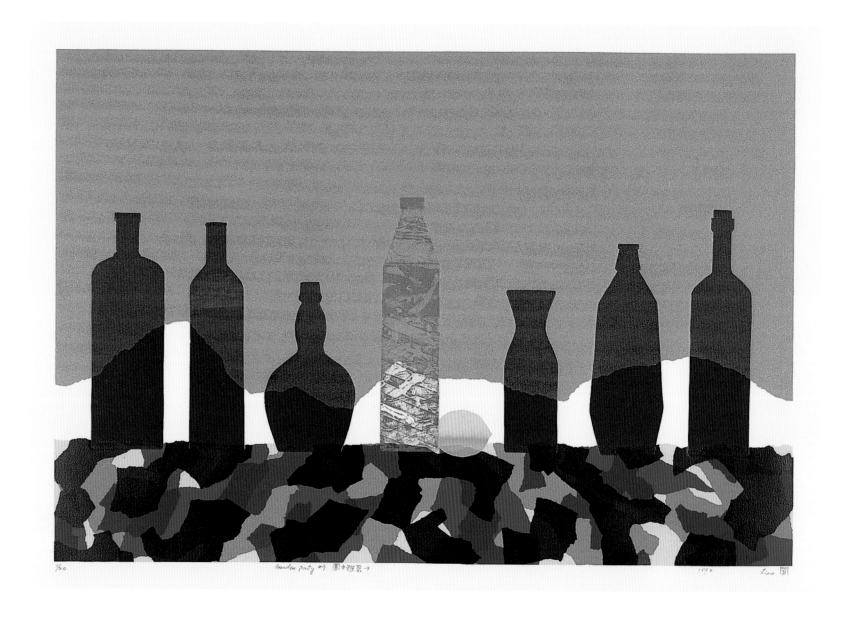

園中雅聚 # 9 *Garden Party # 9*

1992
絲網版、紙凹版 .、金屬蝕刻版 Silkscreen, Collagraph, Etching
54×81 cm

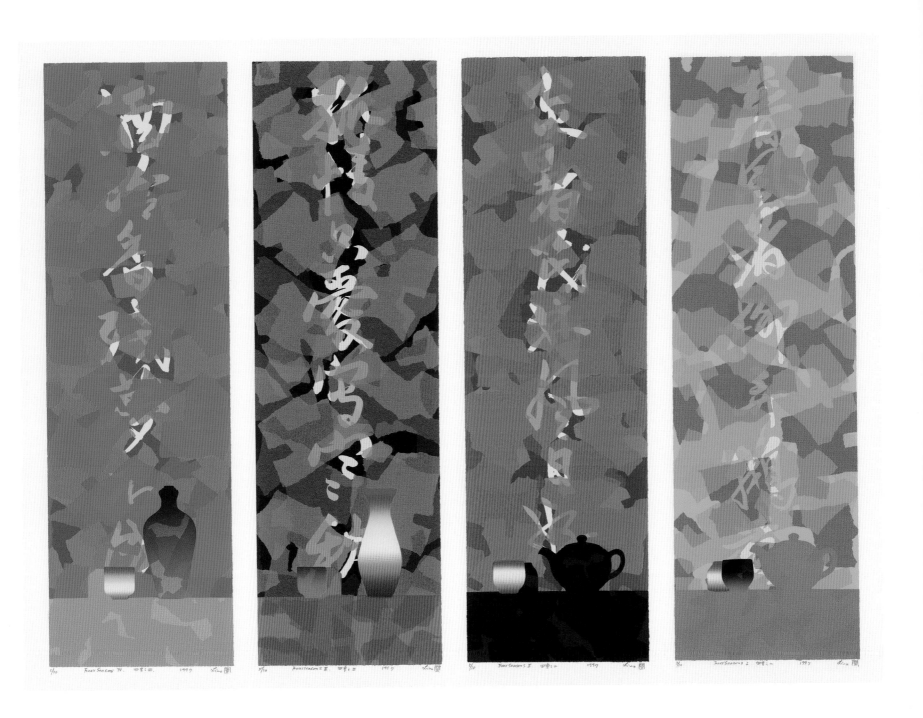

四季 (一)(二)(三)(四) *Four Seasons I II III IV*

1997
絲網版 Silkscreen
91×29 cm×4

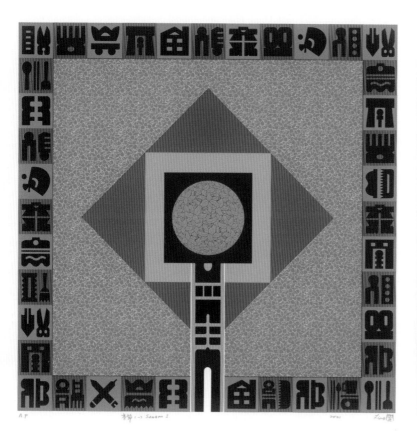

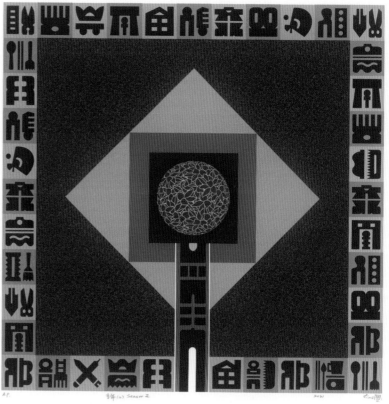

季節 (一)(二)(三)(四) *Season I II III IV*

2021

絲網版 Silkscreen

66×66 cm×4

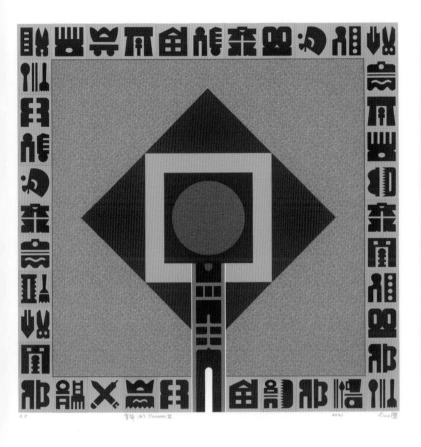

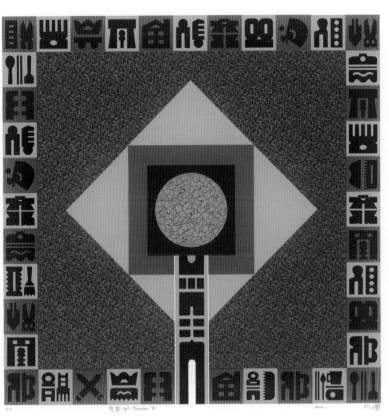

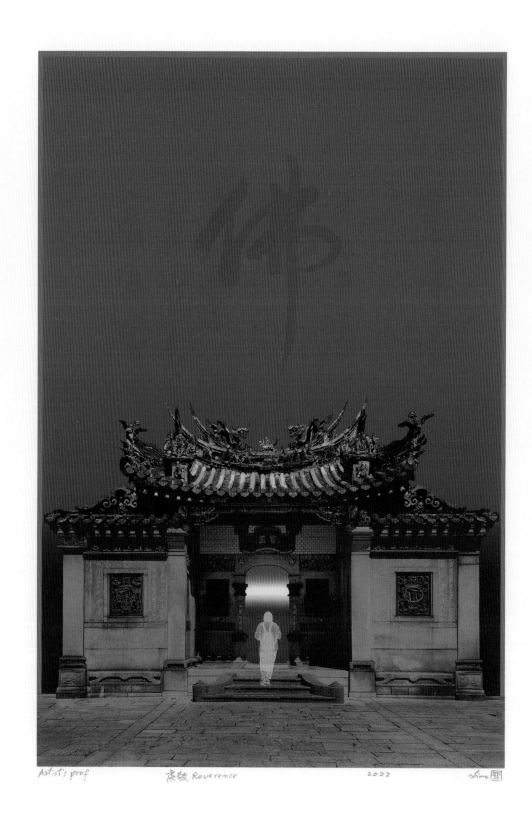

虔敬 *Reverence*

2022
絲網版 Silkscreen
75×50 cm

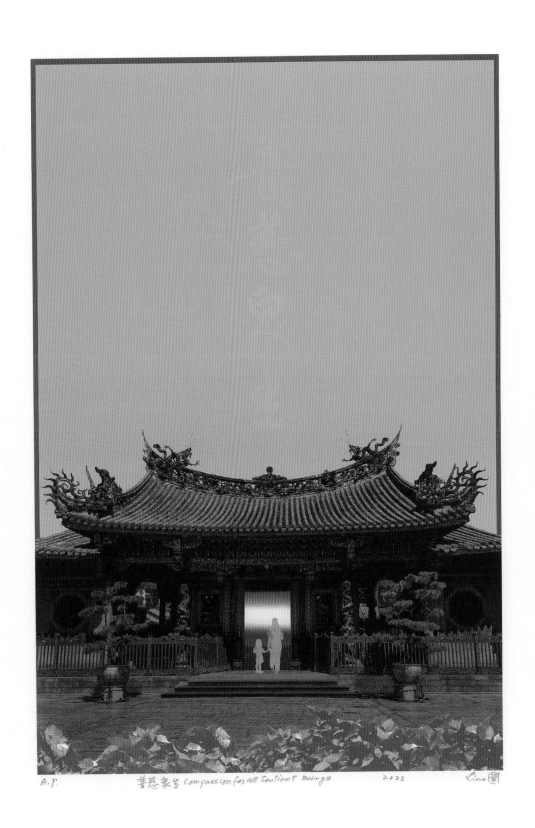

普慈眾生
Compassion for All Sentient Beings

2022
絲網版 Silkscreen
75×50 cm

陶瓷彩繪

Ceramic Painting

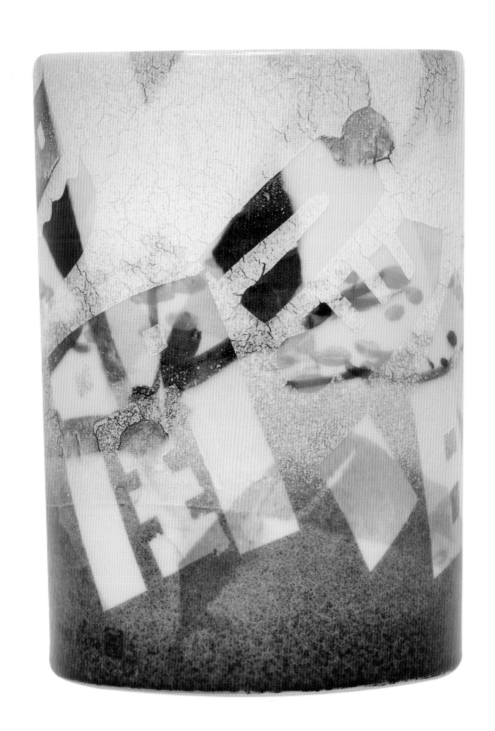

憶 *Reminiscence*

2003
陶瓷彩繪 Ceramic painting
H : 30cm　　Diam : 21.5cm

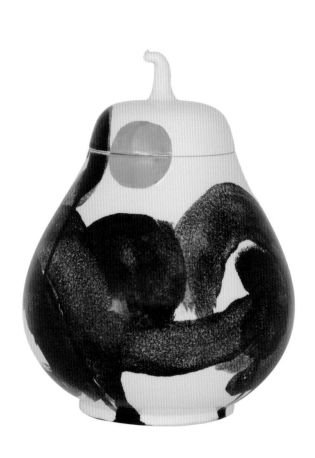

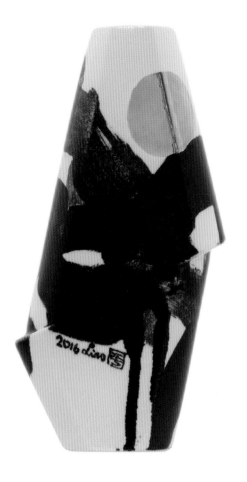

朝 *Morning*

2016
陶瓷彩繪 Ceramic painting
H : 36cm Diam : 26cm

暉 *Sunshine*

2016
陶瓷彩繪 Ceramic painting
H : 25.5cm W : 12cm D : 11 cm

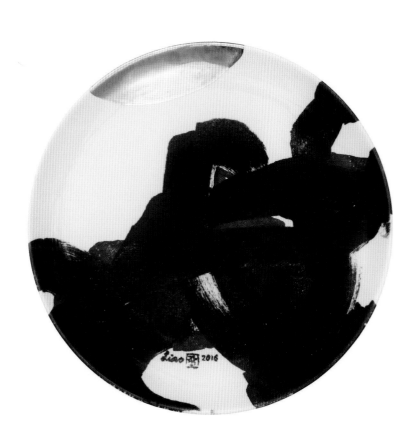

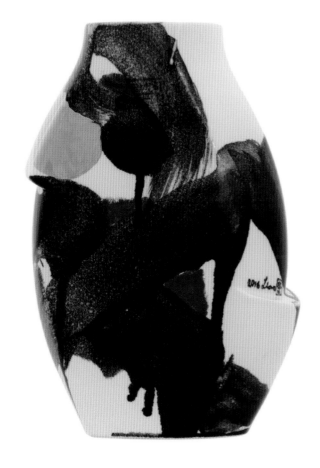

曜 *Luminous*

2016
陶瓷彩繪 Ceramic painting
Diam : 37cm

穎 *Shine*

2016
陶瓷彩繪 Ceramic painting
H : 29cm　W : 20cm　D : 9.5cm

廖修平 Liao Shiou-Ping

◆ 履歷

現任

國立臺灣師範大學講座教授、名譽藝術學博士。

台灣美術院院長（2009-2020），2021起為台灣美術院名譽院長。

臺灣今日畫家協會名譽理事長。

1936　生於臺灣臺北市。

1959　國立臺灣師範大學美術系（48級）畢業。

1962~64　留學日本國立東京教育大學繪畫研究科畢業。

1965~68　旅居巴黎，進入法國國立巴黎美術學院油畫教室，受教於夏士德（Roger Chastel）教授，以及版畫十七工作室（Atelier 17）進修，受教於海特（Hayter）教授。

1968　移居美國，入普拉特藝術學院附設版畫中心擔任助教，並開始於紐約從事藝術創作及活動。

1973~76　回臺提倡現代版畫，任教於臺灣師大、文化大學、藝專、指導與示範版畫製作。

1977~79　應日本國立筑波大學之邀，設立版畫工作室並任教二年半。

1979　返紐約繼續從事藝術創作並執教美國西東大學（Seton Hall University）藝術系版畫課程（至1992）。

2002迄今　回臺繼續從事藝術創作，曾執教臺北市立教育大學、國立臺北藝術大學造形所、國立臺灣藝術大學版畫研究所等多所院校，持續推廣版畫藝術。

曾參加日本、韓國、法國、美國、挪威、埃及、阿根廷等地的國際版畫展獲獎多次，並於世界各大都市，如：東京、巴黎、紐約、北京等地舉行個展，及各地美術機構及學術研究中心等地聯展，如：東京近代美術館、法國巴黎大皇宮、英國倫敦大英博物館、紐約惠特尼美術館、上海美術館、臺北市立美術館、北京中國美術館等。

◆ 個展

2022　「迴歸：廖修平藝術的符號文脈」，國立國父紀念館，臺北，臺灣。

「福臨美至：2022廖修平作品展」，金門縣文化局，金門。

2021　「廖修平：跨越疆界的最前線」，臺南市美術館，臺南，臺灣。

2019　「樸素高貴：廖修平的藝術歷程」，尊彩藝術中心，臺北，臺灣。

「廖修平的藝術：跨域·多元藝術」，馬來西亞國家美術館，吉隆坡。

2018　「樸素的符號·高貴的美感：廖修平繪畫展2000-2018」，龍門畫廊，黃竹坑，香港。

2016　「福彩·版華：廖修平之多元藝道」，國立歷史博物館，臺北。

「Masterpiece Room——廖修平作品展」，國立臺北藝術大學關渡美術館，臺北。

2015　「符號藝術——廖修平創作展」，臺灣國際創價學會，宜蘭、花蓮、臺東。

2014　「版·畫·交響——廖修平創作歷程展」，高雄市立美術館，臺灣。

2013　「跨域·典範——廖修平的真實與虛擬」，中華文化總會，臺北，臺灣。

2012　「界面·印痕——廖修平與臺灣現代版畫之發展」，國立臺灣美術館，臺灣。

2011　「臺灣現代版畫的播種者——廖修平」，紐約雀兒喜美術館，美國。

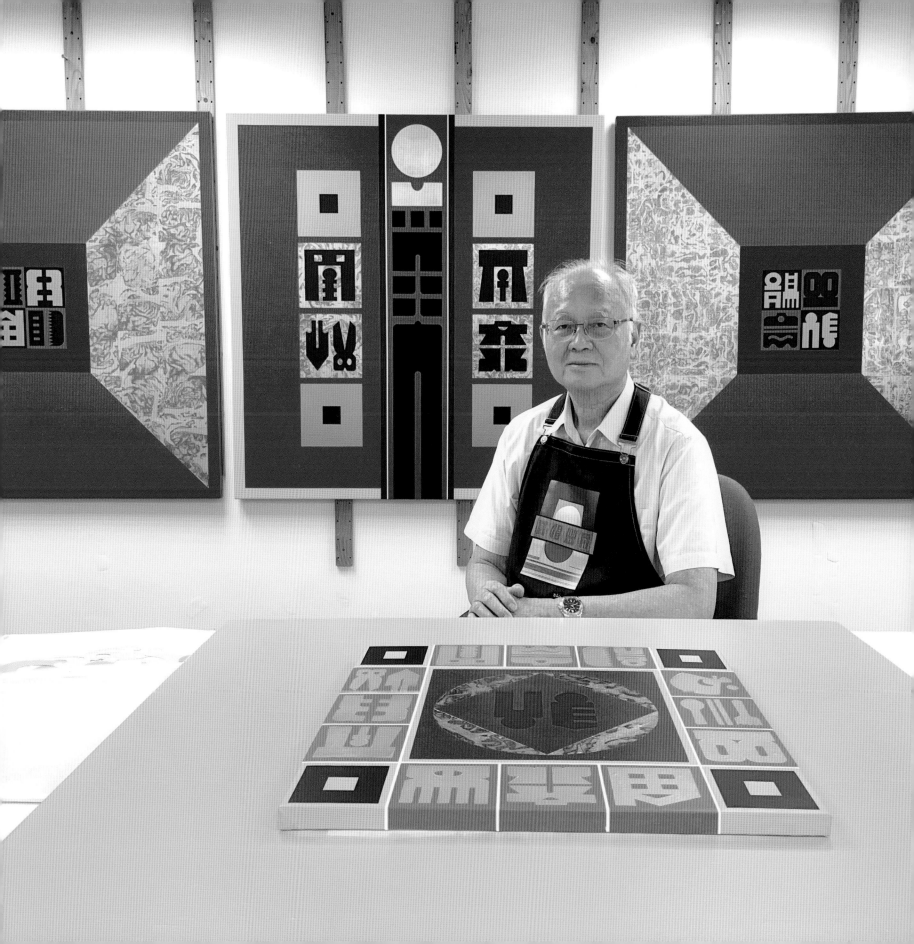

2010 「文化尋根 建構臺灣美術百年史」創價文化藝術系列展覽－
「臺灣現代版畫播種者──廖修平個展」，
臺灣創價學會藝文中心巡迴展。

2009 「福華人生──廖修平作品展」，
北京中國美術館，中國。
「廖修平作品展」，
東京澀谷區立松濤美術館，日本。

2008 「符號人生‧無語問天」，
臺南市立文化中心，臺灣。

2007 「符號人生‧夢境系列」，
臺北國父紀念館，臺灣。
「符號人生‧夢境系列」，
臺中縣立港區藝術中心，臺灣。

2001 「門和四季之敘系列」，
舊金山中華文化中心，美國。
「版畫師傅：廖修平版畫回顧展」，
國立歷史博物館，臺北，臺灣。

2000 蒙特婁市方謝古藝術文化中心，加拿大。
香港藝術中心，中國，香港。
門戶之「鑑」：廖修平的符號藝術，
臺北市立美術館，臺灣。

1999 國立中央大學藝文中心，臺灣。
臺北福華沙龍國際藝術博覽會，臺灣。

1998 巴黎國際藝術城，法國。

1997 東京薇苑畫廊，日本。
西格瑪畫廊，紐約，美國。

1994 積禪五十藝術空間，高雄，臺灣。

1993 上海美術館，中國。

1992 烈日市立現代美術館，比利時。
臺灣省立美術館，臺中，臺灣。

1991 東京線條屋美術館，日本。
江蘇省立美術館，南京，中國。

1990 紐約蘇河區喜格瑪畫廊，美國。
臺南市立文化中心，臺灣。

1989 臺北市立美術館，臺灣。

1988 漢城裕奈畫廊，韓國。

1986 華盛頓國際畫廊，美國。

1985 新澤西州猶太文化中心，美國。

1984 東京松屋畫廊，日本。
雷廷根雷市立美術館，德國。

1983 高雄市立文化中心，臺灣。

1982 臺北國立歷史博物館（國家畫廊），臺灣。
洛杉磯辛諾畫廊，美國。

1981 費城華那特畫廊，美國。
紐約新社會學院，美國。

1980 80畫廊 多倫多 加拿大

1979 東京白田畫廊，日本。
臺北龍門畫廊，臺灣。
漢城裕內畫廊，韓國。

1978 紅畫廊 京都，日本。
紐約州德曼學院藝廊，美國。

1977 新澤西州西東大學藝術中心，美國。
札幌克拉克畫廊，日本。

1976 臺北省立博物館，臺灣。

1975	紐約鈴木畫廊，美國。
	北新澤西藝術中心，美國。
	香港中文大學校外進修部，香港。
1974	東京小造型畫廊，日本。
	馬德里歐斯馬畫廊，西班牙。
1973	費城華那特畫廊，美國。
	舊金山加州榮譽宮殿（版畫部），美國。
1972	波士頓亞洲畫廊，美國。
	臺北國立歷史博物館（國家畫廊），臺灣。
1970	辛辛那提塔佛托美術館，美國。
1969	倫敦薩地畫廊，英國。
1968	墨爾本克羅蘇里畫廊，澳洲。
	巴黎思威特畫廊，法國。
	比利時那慕文化會館，比利時。
	邁阿密現代美術館，佛州，美國。
1967	巴黎藝術之家，法國。
	布宜諾斯艾利斯造型畫廊，阿根廷。
	維也納"道"畫廊，奧地利。
1966	臺北省立博物館，臺灣。
1964	東京造型畫廊，日本。

◆ 獲獎

2018	國立臺灣師範大學名譽藝術學博士學位
2016	第三屆教育部藝術教育終身成就獎
2012	日本版畫協會國際名譽會員
2010	第二十九屆行政院文化獎
2006	第五屆埃及國際版畫三年展，優選獎
1998	中華民國第二屆國家文藝獎，美術類
1995	第四屆李仲生基金會現代繪畫獎成就獎
1993	中國版畫版種大展全國第五屆三版展，傑出貢獻獎
1993	挪威國際版畫三年展，銀牌獎
1980	韓國漢城國際小版畫大獎
1979	吳三連文藝獎
1976	中華民國版畫會，金璽獎
1974	中山文藝創作獎
1973	中華民國十大傑出青年獎
1972	紐約州羅却斯特市宗教美術展，版畫首獎
	巴西聖保羅國際版畫展，優選獎
	美國新澤西州藝術委員會版畫藝術創作獎
1971	美國波士頓版畫家展優選獎
	(作品為麻省 DeCordova Museum 收藏)
1970	東京國際版畫雙年展，佳作獎
	紐約奧杜龐藝術家展，版畫首獎
1969	紐約普拉特版畫家展，佳作獎
1968	法國第 3 屆波爾多雙年展，佳作獎
1966	第 21 屆臺灣省展西畫類第一名
1965	法國春季沙龍，銀牌獎
1964	日本東京示現會展，首獎
1963	入選第六屆日本帝展
1959	全省美展西畫類第三名

◆收藏機構

中華民國臺南市美術館

中華民國國立歷史博物館

中華民國國立臺灣美術館

中華民國臺北市立美術館

中華民國高雄市立美術館

中國北京中國美術館

中國香港藝術館

中國江蘇省美術館

中國上海美術館

中國黑龍江省美術館

中國廣東美術館

日本國立東京近代美術館

日本町田市立國際版畫美術館

韓國漢城國立現代美術館

英國倫敦南倫敦美術館

英國倫敦維多利亞阿爾伯特美術館

英國利物普沃可而美術館

英國倫敦大英帝國博物館

法國巴黎國立圖書館

法國巴黎市立現代美術館

義大利托里諾國際美學研究中心

比利時布魯塞爾皇家歷史美術館

比利時烈日市立現代美術館

比利時那慕文化會館

西班牙馬德里當代藝術館

奧地利維也納阿爾博蒂那博物館

德國法蘭克福工藝博物館

美國紐約大都會博物館

美國俄州辛辛那提美術館

美國佛州邁阿密現代美術館（已關閉）

阿根廷布宜諾斯艾利斯版畫美術館

以色列海華現代美術館

馬來西亞國家美術館

紐西蘭基督城美術館

◆ BIOGRAPHY

Chair Professor at National Taiwan Normal University.

Awarded Honorary Doctorate Degree in Fine Arts, from National Taiwan Normal University.

Honorary Director of Taiwan Academy of Fine Arts (2021-current), Director of Taiwan Academy of Fine Arts (2009-2020).

Honorary Director of Association of Taiwan Artist Today.

1936 Born in Taiwan

1959 Graduated from National Taiwan Normal University, Fine Arts B.A.

1962~64 Continued his studies at Tokyo University of Education, Japan

1965~68 Studied at L'ecole des Beaux-Arts, Paris, France under R. Chastel and at Atelier 17 under S. W. Hayter

1969 Moved to New York City, U.S.A.

1973~76 Returned to Taiwan and taught printmaking at National Taiwan Normal University, Chinese Culture University and National Taiwan Academy of Arts

1977 Invited by Tsukuba University, Japan to set up a printmaking workshop and taught there for two and half years

1979~92 Adjunct professor of Arts at Seton Hall University in New Jersey for 12 years

1988~91 Invited by Zhejiang Academy of Fine Arts and Nanjing Academy of Fine Arts in China as Visiting Professor in the Printmaking Department

1994 Founded the Paris Foundation of Art with Shaih Lifa and Chen Tsing-Fang

2002 to present Moved back to Taiwan and focus on painting and printmaking creations. Teaching printmaking at Taipei National University of Arts, Taiwan University of Arts, and Taiwan Normal University, Department of Continuing Education (Master of Arts Program)

Liao Shiou-Ping has participated in and won awards in international printmaking exhibitions held in Japan, South Korea, France, the United States, Norway, Egypt, and Argentina. He has also held solo exhibitions in major cities worldwide, including Tokyo, Paris, New York, and Beijing, as well as taken part in joint exhibitions organized by art institutions and academic research centers, such as the National Museum of Modern Art Tokyo in Japan; the Grand Palais in Paris, France; the British Museum in London, England; the Whitney Museum of American Art in New York, USA; the China Art Museum, Shanghai in China; the Taipei Fine Arts Museum in Taiwan; and the National Art Museum of China in Beijing, China.

◆ SOLO EXHIBITIONS

2022 "Return: The Semiotic Context of Liao Shiou-Ping's Works", National Dr. Sun Yat-sen Memorial Hall, Taipei, Taiwan, R.O.C.

"Liao Shiou-ping: The Art of Printmaking in Kinmen", Cultural Affairs Bureau of Kinmen County, R.O.C.

2021 "LIAO: Frontline/Frontier, A Retrospective of Liao Shiou-ping", Tainan Art Museum Building 2, Taiwan.

2019 "Simple Noble: The Artist Careers of Liao Shiou-Ping", Liang Gallery, Taipei, Taiwan.

"The Art of Liao Shio-Ping : Cross Region · Diverse approaches", National Art Gallery, Malaysia.

2018 "Simple Symbols · Noble Æsthetics : Liao Shiou-Ping Paintings 2000-2018", Longmen Art Projects, Hong Kong.

2016 "Vivid Colors · Vigorous Life : Liao Shiou-Ping, a Mixed Media Retrospective", National Museum of History, , Taipei, Taiwan, R.O.C.

"Masterpiece Room: Liao Shiou-Ping and His artworks", Kuandu Museum of Fine Arts, Taipei National University of the Arts, Taiwan, R.O.C.

2015 "The Art of Symbols - An Art Exhibition of Liao Shiou-Ping", Taiwan Association Art Center, Yilan, Hualien, Taitung, Taiwan, R.O.C.

2014 "A Symphony of Printmaking and Painting: The Art of Liao Shiou-Ping", Kaohsiung Museum of Fine Arts, Taiwan, R.O.C.

2013 "Cross-domain Paradigms : The Real and Virtual Imagery of Shiou-Ping Liao", The General Association of Chinese Culture (GACC), Taipei, Taiwan, R.O.C.

2012 "Interface·Imprint – Shiou-Ping Liao and the Development of Modern Printmaking in Taiwan", National Taiwan Museum of Fine Arts, Taiwan, R.O.C.

2011 "The Pioneer of Modern Printmaking in Taiwan–Liao Shiou-Ping", Chelsea Art Museum, New York City, U.S.A.

2010 "Searching for the Root of Culture"-Constructing the Centennial History of Taiwanese Art

"A Pioneer of Taiwanese Modern Print"- Selected Works of Liao Shiou-Ping, Taiwan Association Art Center, Taiwan, R.O.C.

2009 "Exhibition of Art Works by Liao Shiou Ping", National Art Museum Of China, Beijing, China

"Liao Shiou-Ping Solo Exhibition", The Shoto Museum of Art, Tokyo, Japan

2008 "Symbols of Life –Speechless Pray", Tainan Municipal Cultural Center, Tainan, Taiwan, R.O.C.

2007 "Symbols of Life – Dream Series", National Dr. Sun Yat-sen Memorial Hall, Taipei, Taiwan, R.O.C.

"Symbols of Life – Dream Series", Taichung County Seaport Art Center, Taichung, Taiwan, R.O.C.

2001 "Gate Series and Seasonal Chat Series", Chinese Culture Center, San Francisco, California, U.S.A.

"The Master of Printmaking", National Museum of History, Taipei, Taiwan, R.O.C.

2000 Marche Bonsecours, Montreal, Canada
Hong Kong Arts Centre, Hong Kong, Chin

"Significance of gates: art of icons by Liao Shiou-ping" Taipei Fine Arts Museum, Taiwan, R.O.C.

1999 Art Center of National Center University, Chung-Li, Taiwan, R.O.C.

Taipei Art Fair International 1999, Taiwan, R.O.C.

1998 Cite internationale des Arts, Paris, France

1997 Vivant Gallery, Tokyo, Japan
Sigma Gallery, Soho, New York City, U.S.A.

1994 G. Zen Art Gallery, Kaohsiung, Taiwan, R.O.C.

1993 Shanghai Art Museum, Shanghai, China

1992 Museum of Modern Art, Liege, Belgium

Taiwan Museum of Art, Taichung, Taiwan, R.O.C.

1991 Striped House Museum of Art, Tokyo, Japan

Jiangsu Provincial Arts Museum, Nanjing, China

1990 Sigma Gallery, Soho, New York City, U.S.A.

Tainan Municipal Cultural Center, Taiwan, R.O.C.

1989 Taipei Fine Arts Museum, Taipei, Taiwan, R.O.C.

1988 Yuna Gallery, Seoul, Korea

1986 Gallery International, Washington D.C., U.S.A.

1985 J.C.C. Culture Center, Tenafly, New Jersey, U.S.A.

1984 Matsuya Gallery, Tokyo, Japan

Oberschlesisches Landesmuseum, Ratingen, Germany

1983 Avante Guard Art Center, Taichung, Taiwan, R.O.C.

Kaohsiung Culture Center, Taiwan, R.O.C.

1982 National Art Gallery, National Museum of History, Taipei, Taiwan, R.O.C.

Shinno Gallery, Los Angeles, California, U.S.A.

1981 Walnut Gallery, Philadelphia, U.S.A.

The New School, New York City, U.S.A.

1980 Gallery "80", Toronto, Canada

1979 Shirota Gallery, Tokyo, Japan

Lung Men Art Gallery, Taipei, Taiwan, R.O.C.

Yuna Gallery, Seoul, Korea

1978 Beni Gallery, Kyoto, Japan

Dasmen College Art Gallery, Amherst, New York, U.S.A.

1977 Seton Hall Univ. Art Center, South Orange, New Jersey, U.S.A.

Clark Gallery, Sapporo, Japan

1976 Taiwan Provincial Museum, Taipei, Taiwan, R.O.C.

1975 Suzuki Gallery, New York City, U.S.A.

Art Center of Northern New Jersey, Tenafly, N.J., U.S.A.

Dept. of Extramural Studies, Chinese University, Hong Kong, China

1974 Osma Gallery, Madrid, Spain

1973 Walnut Gallery, Philadelphia, Pennsylvania, U.S.A.

California Palace of Legion of Honor, San Francisco, U.S.A.

1972 Art Asia Gallery, Boston, Massachusetts, U.S.A.

National Art Gallery, National Museum of History, Taipei, Taiwan, R.O.C.

1970 The Taft Museum, Cincinnati, Ohio, U.S.A.

1969 Zaydler Gallery, London, U.K.

1968 Crossley Gallery, Melbourne, Australia

Maison de la Culture, Namur, Belgium

Miami Museum of Modern Art, Miami, Florida, U.S.A.

1967 Maison des Beaux-Arts, Paris, France

Plastica Galeria de Arte, Buenos Aires, Argentina

Galerie TAO, Vienna, Austria

Galerie 16, Graz, Austria

1966 Taiwan Provincial Museum, Taipei, Taiwan, R.O.C.

1964 Zokei Gallery, Tokyo, Japan

◆ AWARDS

2018 Honorary Degree of Doctor of Philosophy in Fine Arts, Awarded by National Taiwan Normal University.

2016 Honorary Academy Award, 3rd Arts Education Contribution Award, Taiwan, R.O.C.

2012 International honorary members, Japan Print Association.

2010 The 29th National Cultural Award, Taiwan, R.O.C.

2006 Honorary prize of the 5th Egyptian International Print Triennial Exhibition, Egypt

1998 National Award for Arts, Taiwan, R.O.C.

1995 The 4th Li Chun-Shen Modern Painting Award, Taiwan, R.O.C

1993 Outstanding Contribution Award, The 5th China Exhibition of 3 kind Print, Xi'an, China.
Silver Medal, Norwegian International Print Triennial, Norway.

1980 Grand Prize of 1st International Miniature Print Exhibition, Seoul, Korea.

1979 Wu San Lien Creative Arts Award, Taiwan, R.O.C.

1976 The Best Printmaker Award, Chinese Graphic Society, Taiwan, R.O.C.

1972 Graphic Art Mini Grant of New Jersey State Council in the Arts, U.S.A.
Purchase Prize, International Print Exhibition, San Paulo, Brazil.
First Graphic Award, Rochester Festival of Religious Arts, New York, U.S.A.

1971 DeCordova Museum Purchase Prize, Boston Printmaker's Exhibition, Boston, U.S.A.

1970 Honorable Mention, 7th International Print Biennial, Tokyo, Japan.
First Prize, 28th Annual Audobon Artist's Exhibition, New York, U.S.A.

1969 Honorable Mention, Pratt Print Exhibition, New York, U.S.A.

1966 First Prize, Taiwan Provincial Fine Art Exhibition (Western Painting), Taiwan, R.O.C.

1965 Silver Medal, Salon des Artistes Français, Paris, France

1963 Honorable Mention, Tokyo Empire Fine Art School Exhibition, Japan

1959 Third Prize, Taiwan Provincial Fine Art Exhibition (Western Painting), Taiwan, R.O.C.

◆ COLLECTIONS

National Museum of History, Taipei, Taiwan, R.O.C.

National Taiwan Museum of Fine Arts, Taichung, Taiwan, R.O.C.

Taipei Fine Arts Museum, Taipei, Taiwan, R.O.C.

Kaohsiung Museum of Fine Arts, Kaohsiung, Taiwan, R.O.C.

National Art Museum Of China, Beijing, China

Hong Kong Museum of Art, Hong Kong, China

Jiangsu Provincial Arts Museum, Nanjing, China

Shanghai Art Museum, Shanghai, China

Heilongjiang Provincial Museum of Fine Arts, Heilongjiang, China

Guangdong Museum of Art, China

National Museum of Modern Art, Tokyo, Japan

Machida City Museum of Graphic Arts, Machida, Japan

National Museum of Contemporary Art, Seoul, Korea

South London Gallery, London, U.K.

Victoria & Albert Museum, London, U.K.

British Museum, London, U.K.

Walker Art Gallery, Liverpool, U.K.

Bibliothèque Nationale de France, Paris, France

Musée d'Art Moderne de la Ville de Paris, France

International Center of Æsthetic Research, Torino, Italy

Musée d'Art moderne, Liege, Belgium

Maison de la Culture, Namur, Belgium

Museo Espanol de l'Arte Contemporano, Madrid, Spain

Museo de Arte Contemporáneo, Madrid, Spain

Albertina Museum, Vienna, Austria

Museum für Kunsthandwerk, Frankfurt, Germany

The Metropolitan Museum of Art, New York City, U.S.A.

Cincinnati Art Museum, Cincinnati, Ohio, U.S.A.

Miami Museum of Modern Art, Miami, Fl., U.S.A.(closed)

Museo del Grabado, Beunos Aires, Argentina

Haifa Museum of Art, Haifa, Israel

National Art Gallery, Malaysia.

Christchurch Art Gallery, New Zealand.

迴歸：廖修平

Return: The Semiotic Context of Liao Shiou-Ping's Works

藝術的符號文脈

作　者｜廖修平

發行人｜廖修平
出版者｜財團法人福修文化藝術基金會
　　　　地址：10684 台北市仁愛路四段 2 號 3 樓
　　　　電話：02-2702-8515

策展人｜李振明

總編輯｜李振明
執 行 編 輯｜張愛青
專輯文宣設計｜黃媛婷

製版印刷｜鼎峰國際
出版日期｜2022 年 8 月
版　　次｜初版
定　　價｜新台幣 900 元

ISBN｜978-986-95316-3-4（平裝）

Author｜Liao Shiou-Ping

Publisher｜Liao Shiou-Ping
Commissioner｜Fushiou Culture and Arts Foundation
　　　　Address: 3F, No.2, Sec.4, Ren Ai Rd., Taipei City 10684, Taiwan
　　　　TEL: +886-2-27028515

Curator｜Lee Cheng-Ming

Chief Editors｜Lee Cheng-Ming
Executive Editors｜Chang Ai-Ching
Catalogue Design, Graphic Design｜Wong Woon-Ting

Printing｜Devotee International
Publication Date｜August, 2022
Edition｜First Edition
Price｜NT. 900

ISBN｜978-986-95316-3-4

國家圖書館出版品預行編目（CIP）資料

迴歸：廖修平藝術的符號文脈 = Return : the
semiotic context of Liao Shiou-Ping's works/ 廖修
平著. -- 初版. -- 臺北市：財團法人福修文化藝術
基金會, 2022.08
104 面 ; 25 × 26 公分
ISBN 978-986-95316-3-4（平裝）

947.5　　　　　　　　111013634